IMAGES
of America

SANDWICH
CAPE COD'S OLDEST TOWN

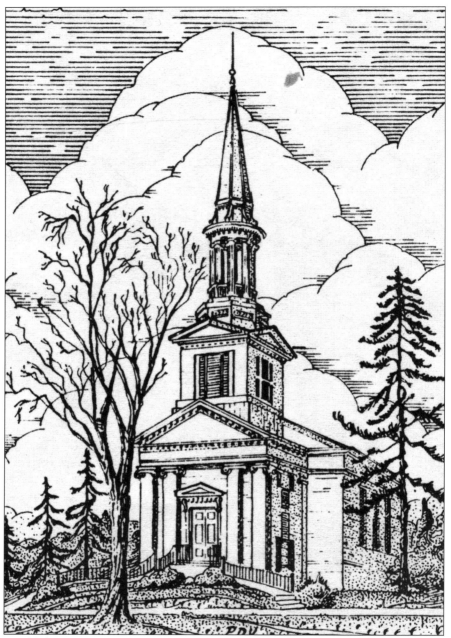

Since establishing a church was a condition of starting a new town, the first Sandwich meetinghouse was built in 1638. The parish was Puritan in belief, later Congregational, for it had no outside governing ecclesiastical authority. Through the years, Unitarian and Methodist parishes federated with the Congregational, although Methodists later withdrew. Today, the First Church of Christ in Sandwich has standing in both the United Church of Christ (Congregational) and the Unitarian Universalist Association. The present building, erected in 1847, has a steeple somewhat like that of St. Marylebone in London, which was designed by Sir Christopher Wren. (Sketch by Pierre D. Vuilleumier.)

IMAGES
of America

SANDWICH
CAPE COD'S OLDEST TOWN

Marion R. Vuilleumier

ARCADIA

First printed in 2001.

Published by Arcadia Publishing,
an imprint of Tempus Publishing, Inc.
2A Cumberland Street
Charleston, SC 29401

Printed in Great Britain.

Library of Congress Catalog Card Number: 2001091706

For all general information contact Arcadia Publishing at:
Telephone 843-853-2070
Fax 843-853-0044
E-Mail sales@arcadiapublishing.com

For customer service and orders:
Toll-Free 1-888-313-2665

Visit us on the internet at http://www.arcadiapublishing.com

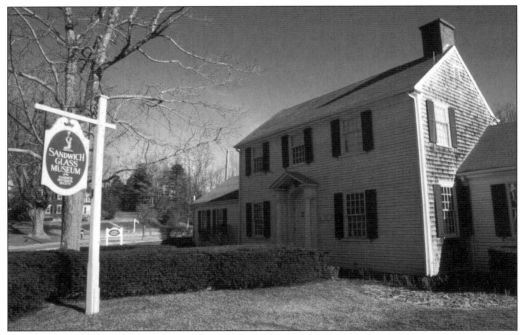

The Sandwich Historical Society, founded in 1907, houses the Sandwich Glass Museum with an authentic, rare collection of glass made by the famous Boston & Sandwich Glass Company from 1825 to 1888. Every known type of glass, from blown, pressed, and cut, was made in the sprawling complex now gone except for its products, the dazzling displays in this museum. The society also has an extensive archive collection. (Courtesy Sandwich Historical Society Archives.)

CONTENTS

ACKNOWLEDGMENTS

Heartfelt appreciation is expressed to the archivists who have helped locate photographs and shared information for this book: Lynne M. Horton, curator of history and educational director of the Sandwich Glass Museum; Barbara Gill, archivist for the Sandwich Archives and Historical Center; and Mary Sicchio, special collections librarian at the Cape Cod Community College Archives. Lynne was especially helpful as liaison with the publisher. I am also grateful to Sandwich historian Russell A. Lovell Jr. for helpful suggestions and for his book *Sandwich: A Cape Cod Town*, which was an excellent research source. Also helpful were people who contributed photographs and artwork: David Wheelock, curator of the homestead for the Wing Family of America; John Cullity and Rosanna Cullity of the Nye Family of America Association; Joan DiPersio of the Green Briar Nature Center and Jam Kitchen; the Bourne Historical Society; Barbara Gill from her personal collection; and my son Louis Vuilleumier for his sketches. Also, I am most pleased to be able to use sketches by my late husband, the Reverend Dr. Pierre D. Vuilleumier.

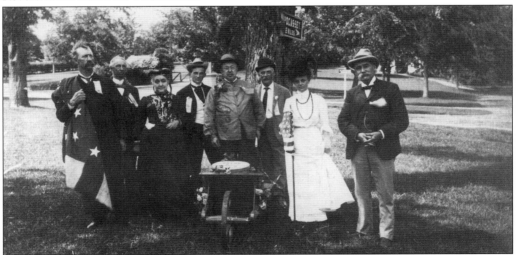

Part of the festivities of the Wing family reunion in 1902 was the Butter Parade, at which the members presented to the selectmen a firkin of butter, because that is how their ancestors paid their taxes in 1652–1653. John Mansir Wing of Chicago is custodian of the butter barrow. The ladies are Mrs. George Wing Sisson (left) and Angela Wing. (Courtesy Wing Family of America.)

INTRODUCTION

In 1637, when 10 men of Saugus were given permission by the leaders of Plimoth Colony to establish Sandwich, the first town on Cape Cod, they found a verdant landscape dotted with ponds and veined with streams. It was bounded on the north by Cape Cod Bay and on the west and southwest by another body of water, since the territory then included the present-day town of Bourne. Soon the settlers had cut the virgin forest and built homes, a meetinghouse, a mill, and a tavern. Fishing and farming provided a good living, and trading developed with Plimoth and other nearby towns. Soon corn and lumber were transported by boat to other towns on Cape Cod Bay, while flocks of sheep trotted along cartways, bringing their mutton to market. In this atmosphere, Sandwich grew and thrived as more people came. Each year, residents plowed their fields and reaped harvests from the sea and the land in this pastoral setting.

Those early residents would have never imagined that nearly two centuries later this bucolic atmosphere would change into that of a bustling factory town and this shift would be the first of many increasingly rapid changes to come in the years ahead.

By the late 1700s, Bostonians had discovered that Sandwich, a town often visited by lawyer and congressman Daniel Webster, was a relaxing place to escape hectic Boston and enjoy hunting and fishing. Visiting businessmen also "saw in the wooded hills and flashing streams . . . fuel here, water power there, and smokestacks and factories everywhere," according to Harriot Barbour in *Sandwich: The Town That Glass Built*. One of these entrepreneurs was glass manufacturer Deming Jarves, who noted an inexhaustible supply of fuel for his fires, an abundant supply of salt marsh hay for packing, and a navigable creek for raw materials and finished goods.

Quietly, his agent visited locals, purchasing 3,000 acres of woodland and 300 acres near the creek. In 1825, at a special town meeting, Jarves surprised the residents with his plans for the Boston & Sandwich Glass Company, promising work for the townsfolk. Three months later, the Industrial Revolution arrived in Sandwich, when Jarves wrote, "Ground was broken in April, dwellings for workmen built, and manufactory complete, and on the 4th day of July 1825, they commenced blowing glass." At its peak, the factory employed about 500 workers, with professional glassblowers brought from overseas. For the next 63 years, smoke from the factory's chimneys hung like a pall over the town, but its products gave the opposite effect, for the jewel-like blown, pressed, and cut glass made Sandwich famous both in this country and abroad.

Soon the new company attracted support services and other small businesses. Some were a tag factory, a braiding company, a tack factory, the Boston & Sandwich Boot and Shoe Company, blacksmith shops, an iron foundry, and a factory making wagons, carts, and sleighs. Other glassmakers opened factories also: the Packwood-Northwood Glass Company and the Cape Cod Glass Works. The latter establishment was built and owned by Deming Jarves and a few shareholders.

A century or so later, the population of Sandwich had spread into eight villages and there was talk of dividing the town, since it was such a distance to churches and polling places. By then, a dredge was digging a much-talked-about canal, which had been suggested by Pilgrim governor William Bradford in the 1600s and by Gen. George Washington in the 1700s. They had noted that only eight miles separated the two bays, and a canal between would save ships the hazardous trip around Cape Cod. As early as 1759, petitions to divide the town had begun with no results. In 1884, however, a state delegation came to look over the situation. After seeing the dredge at work on a proposed canal, delegates could see that the future would be even more difficult for residents if a canal was actually coming. Thus, members brought a favorable report for division to the Massachusetts legislature. When the governor signed the bill on April 2, 1884, the new town Bourne, the last of the 15 on Cape Cod, came into existence.

Changes were rapid now. The iron horse arrived in Sandwich in 1848, gradually supplanting the stagecoaches. Captains of whalers and clipper ships ranged the globe, bringing exotic goods to residents and giving them world news.

Life accelerated especially when the oft attempted canal was finally brought to fruition by August Belmont in 1914. There were new bridges, as well as rerouted highways and rail line configurations. Great was the celebrating at the festive opening on July 29, 1914, when the governor arrived to salute the achievement. Ships from New Bedford, accompanied by a U.S. Navy destroyer, and six palatial yachts paraded through the new canal. Although the Cape Cod Canal officially opened for business the following day, the celebration continued, for on August 15 and 17–19, four free performances of *The Pageant of Cape Cod* were held outdoors near the Bourne Bridge. The drama's 15 acts presented the history of Cape Cod.

Meanwhile, trouble was brewing in Europe that would bring even more drastic changes to Sandwich and the whole country. As early as 1904, soldiers had been camping and training summers around Sandwich ponds. With war clouds coming closer, the tempo of training grew. Since 1911, part of Shawme Crowell State Forest had been used by the National Guard for artillery firing and field training. The New England troops that trained in Sandwich subsequently became the 26th Division, known eventually as the Yankee Division when serving in World War I. This area would be a loading point for troops in both world wars.

Before the outbreak of World War II, more changes came when the canal was deepened and widened and new bridges were built, including a railway lift bridge. By this time, both the telephone and electricity had arrived, each making their Cape debut in Sandwich, according to Russell Lovell Jr. in *Sandwich: A Cape Cod Town*. The telephone had been demonstrated on April 11, 1878, in the Sandwich Town Hall, and electric lights appeared in the casino for just one evening on September 8, 1889, during the 250th anniversary.

More wonders appeared in the 1900s, not the least of which was the increased influx of summer visitors and day trippers. Some newcomers were artists, such as the impressionistic painters Dodge MacKnight and Theodore Coe. Also, other artists, such as Hazel Blake French, were crafting jewelry from fragments of Sandwich glass.

There were two welcome changes about this time. One was the rise to prominence of native son Thornton W. Burgess, author and naturalist, who brought attention to Sandwich with his tales of the creatures in the Briar Patch in books, newspaper columns, and on radio. The second was the urge of descendants to search out their roots. On the cusp of 1900, the Wing and Nye families preserved their ancestral homes and established reunions. Today, the media highlights the increasing call of residents, newcomers, and governmental agencies for preservation, conservation, and preserving the balance between tourism and development, another welcome change.

One
FARMING, FISHING, AND TRADE

This scene is the way the Sandwich shoreline might have looked before the settlement of the town. The Wampanoags had been here for centuries. In the summer, they lived near the shore in homes made of young, bent trees covered with woven mats. In colder weather, they moved to more permanent long houses inland. (Courtesy Sandwich Town Archives.)

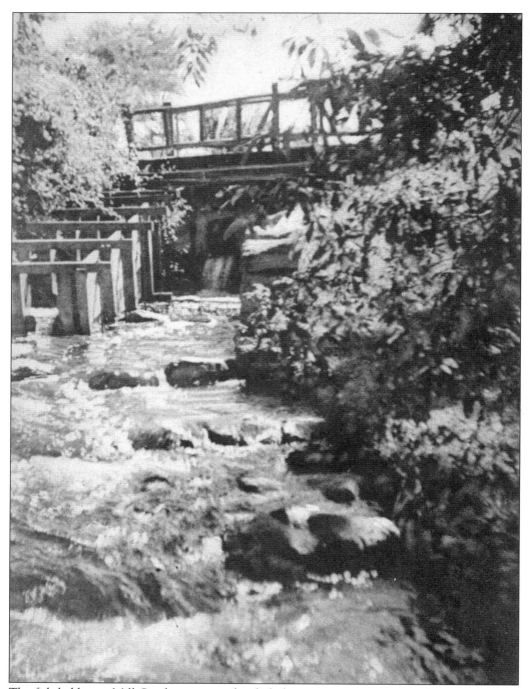

The fish ladder on Mill Creek was created to help herring swim upstream each spring to reach their birthing ponds. Every three years for eons, herring have been returning to their homes on the Cape to spawn. Originally, there were no impediments for their upward swim. However, since dams have been built to generate waterpower, the residents have kept fish ladders to help the herring reach home base. (Courtesy Barbara Gill.)

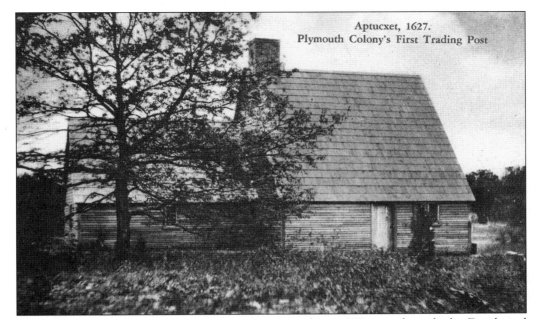

The Pilgrims built a trading post on Monument Neck in 1627 to trade with the Dutch and Native Americans in furs, sassafras, and lumber. This replica was erected in 1930 on the same foundation, as close in design as possible to the original building. (Postcard by Bourne Historical Society; courtesy Sandwich Historical Society Archives.)

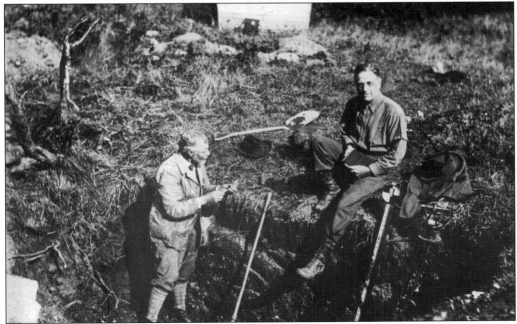

Here, Percival Hale Lombard (left) and Nathan Bourne Hartford are excavating the site of Plimoth Colony's first trading post. Bowls, spoons, clay pipes, a candle holder, and a large key found are on display in the Aptucxet Trading Post Museum, which is open in summer. (Photograph from the Lombard Collection; courtesy Cape Cod Community College Archives.)

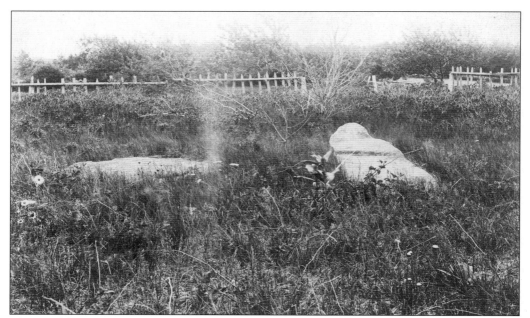

These saddle and pillion stones mark the burial site of Edmand Freeman, a town founder, and his wife, Elizabeth. Located on the former Watson Freeman Farm, off Tupper Road, the stones suggest the means whereby Freeman and his wife often traveled together. (Courtesy Sandwich Historical Society Archives.)

The Tupper Stone on Tupper Road marks the location of the home of these first settlers. It is fairly close to the saddle and pillion burial site. (Photograph by Marion Vuilleumier.)

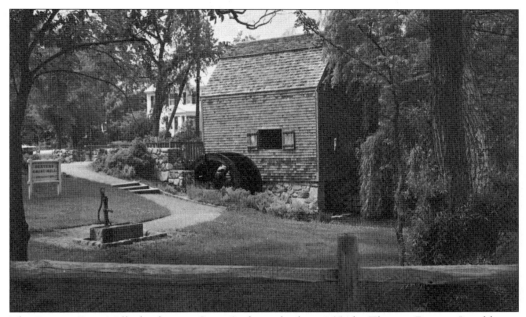

The Dexter Grist Mill, the first on Cape Cod, was built in 1654 by Thomas Dexter. In addition to the grinding mechanism, it housed the miller's family. Through the years, the waterwheel has provided power for carding, cloth dressing, marble working, wheelwrighting, tag making, and printing. It was restored by the town in 1961 and now operates in the summer as an ancient gristmill, grinding corn. (Courtesy Sandwich Historical Society Archives.)

This wind gristmill in Cataumet (then part of Sandwich) dates to the 1700s, according to John Cullity. The mill is featured in *Windmills of Cape Cod*, by Fredrika Burrows. (Courtesy Sandwich Historical Society Archives.)

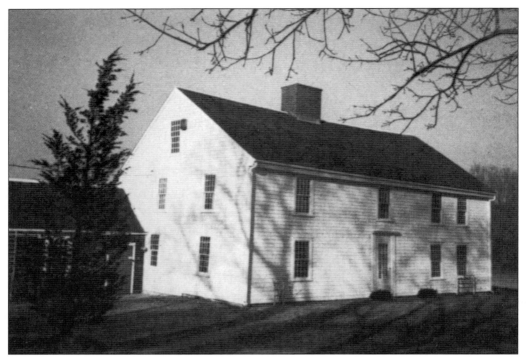

The Wing Fort House on Spring Hill was built in 1641 by Stephen Wing, another town founder. The right front part is reputed to be one of the oldest houses in Sandwich. It was lived in continuously by Wing descendants for three centuries and is now open as a museum in the summer. (Photograph by Marion Vuilleumier.)

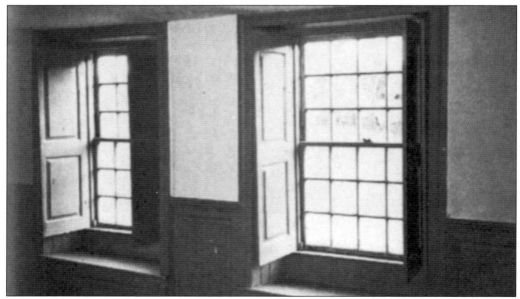

The shutters inside the windows were built in case of trouble, thus the designation fort. (Photograph by Marion Vuilleumier.)

The Wing historical marker is on the
grounds of the Wing Fort House.
(Photograph by Marion Vuilleumier.)

Although sand borders most of the town, there are occasionally rocks left by the glacier, as on
this Sandwich beach. (Courtesy Sandwich Historical Society Archives.)

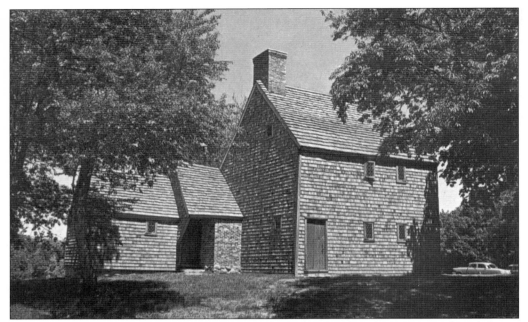

The first recorded owner of the Hoxie House, built shortly after the town was founded, was the Reverend John Smith, who lived here from 1675 to 1688. However, the house is named for whaling captain Abraham Hoxie, who owned it in the mid-1800s. The house was acquired by the town and restored in 1959. (Courtesy Sandwich Historical Society Archives.)

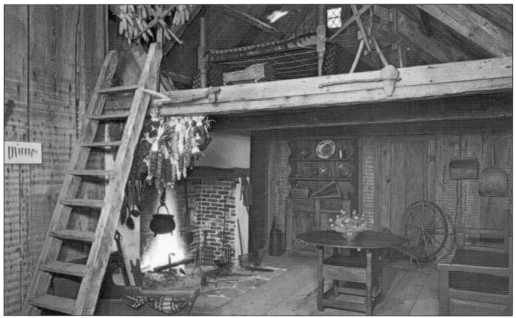

This interior photograph of the Hoxie House shows the keeping room and sleeping loft, restored to the 1675–1680 period. Authentic furnishings were loaned by the Museum of Fine Arts in Boston. (Courtesy Sandwich Town Archives.)

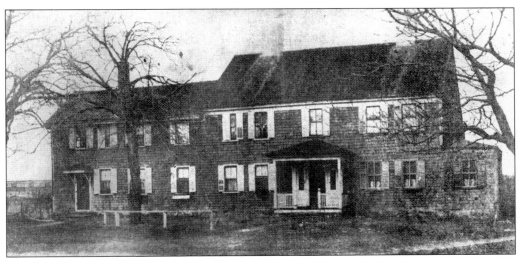

When the Barnstable–Boston stagecoach stopped at Sagamore, Smith's Tavern was the place it changed horses. The original house was built in the mid-1700s, when the land was still part of Sandwich. (Courtesy Bourne Historical Society.)

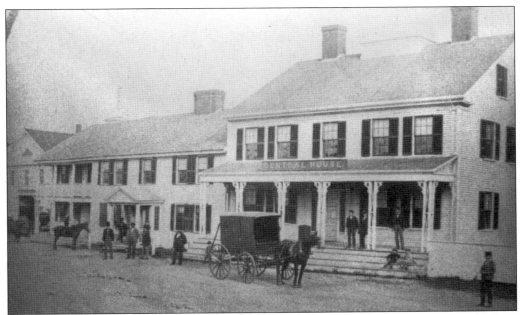

The midsection of the Central House, on Main Street in Sandwich, was the Cotton parsonage, built in 1694. When the left section was added in the 1700s, it became the Fessenden Tavern, headquarters of the patriots during the Revolution. A favorite of Daniel Webster, the inn was named for him in 1915. When fire destroyed it in 1971, it was rebuilt into a modern inn. (Courtesy Sandwich Historical Society Archives.)

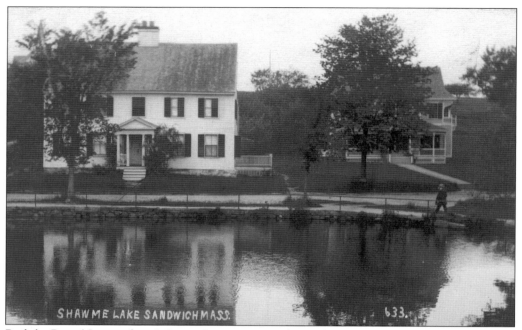

SHAWME LAKE SANDWICH MASS. 633.

Built by Peter Newcomb at 8 Grove Street *c.* 1702, this Colonial-style house was the center for Tories during the Revolutionary period. (Courtesy Sandwich Town Archives.)

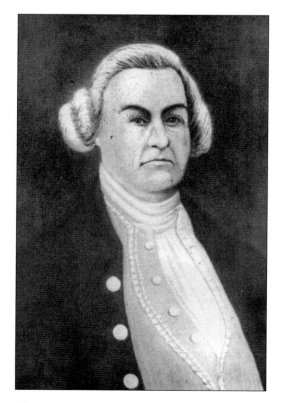

Brig. Gen. Timothy Ruggles was host at the Newcomb Tavern from 1736 to 1753. He had a varied career as a lawyer, judge, representative, and scientific farmer, along with military service. This leading Tory eventually settled in Nova Scotia. (Courtesy Cape Cod Community College Archives.)

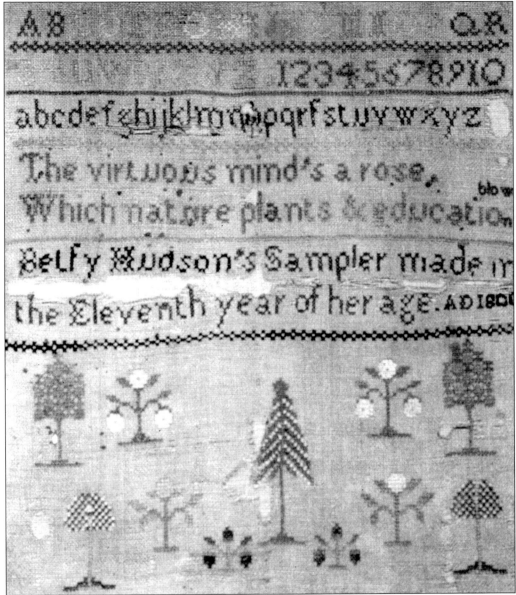

The Betsy Hudson Sampler was donated by Elizabeth Wells in 1981. It is an example of how girls learned needlework in earlier years. (Courtesy Sandwich Town Archives.)

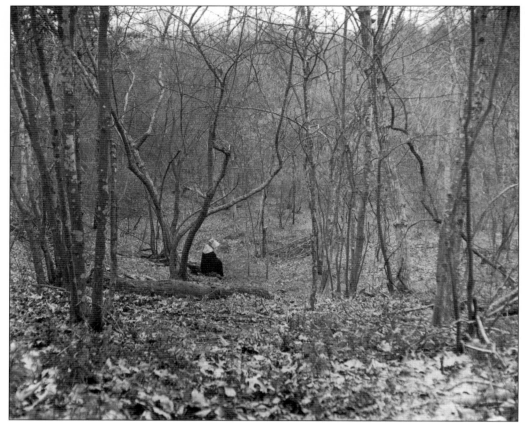

In this glen, Quaker Christopher Holder preached to Sandwich converts in 1656. This reenactment is a reminder that Quakers were not welcomed by the established church, since they refused to pay church taxes. However, 17 families became part of the oldest continuing Quaker meeting in America. (Courtesy Sandwich Town Archives.)

This third Sandwich Friends Meetinghouse on the site was built in 1820. An amazing contrivance resembling a ship's wheel allowed for separate business meetings for men and women. Recently, a community building was added to the property. (Sketch by Pierre D. Vuilleumier.)

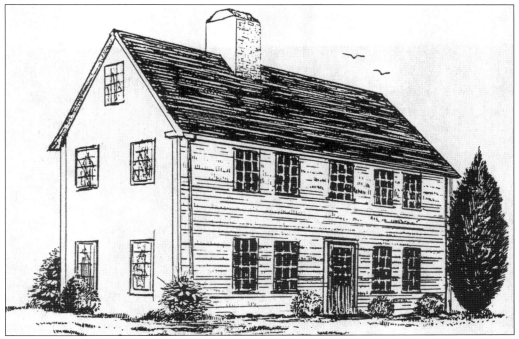

James Skiffe built this house in 1638 as a one-story home. In 1720, it was moved to the Spring Hill location and rebuilt as a two-story house. (Sketch by Louis Vuilleumier.)

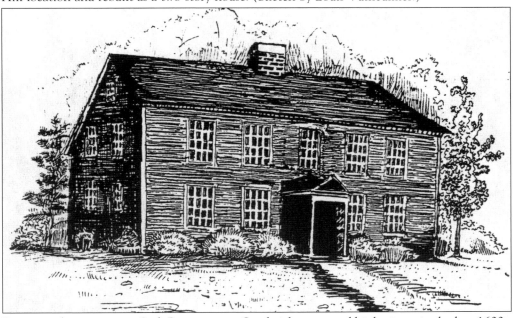

Boston pushcart operator Seth Pope came to Sandwich to expand his business in the late 1600s. Town fathers, considering him an itinerant peddler, asked him to leave. He left but vowed to return. Around 1700, he did return, building this substantial house on Grove Street and another identical one on Tupper Road. There are still Popes living in town. (Sketch by Louis Vuilleumier.)

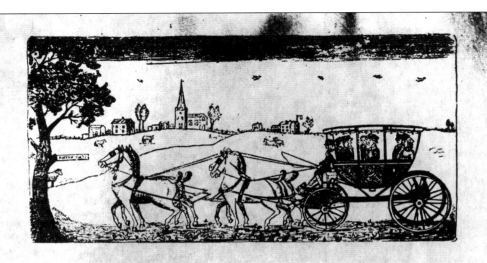

BOSTON,
Plymouth & Sandwich
MAIL STAGE,

CONTINUES TO RUN AS FOLLOWS:

LEAVES Boston every Tuesday, Thursday, and Saturday mornings at 5 o'clock, breakfast at Leonard's, Scituate ; dine at Bradford's, Plymouth ; and arrive in Sandwich the same evening. Leaves Sandwich every Monday, Wednesday and Friday mornings ; breakfast at Bradford's, Plymouth ; dine at Leonard's, Scituate, and arrive in Boston the same evening.

Passing through **Dorchester, Quincy, Wyemouth, Hingham, Scituate, Hanover, Pembroke, Duxbury, Kingston, Plymouth** to **Sandwich.** *Fare,* from Boston to Scituate, 1 doll. 25 cts. From Boston to Plymouth, 2 dolls. 50 cts. From Boston to Sandwich, 3 dolls. 63 cts.

N. B. Extra Carriages can be obtained of the proprietor's, at Boston and Plymouth, at short notice.—STAGE BOOKS kept at Boyden's Market-square, Boston, and at Fessendon's, Plymouth.

LEONARD & WOODWARD.

BOSTON, *November 24,* 1810.

[Reproduced from a print in possession of the Bostonian Society.]

This poster advertises stagecoach travel. (Courtesy Cape Cod Community College Archives.)

William Perry made this carriage for his twins in 1834. It is a miniature of the Sandwich–Boston stagecoach. The original carriage is in the Sandwich Glass Museum. (Courtesy Cape Cod Community College Archives.)

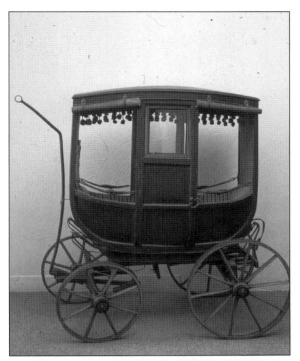

This stone marker near the Hoxie House notes the location of the first private school building, which was erected by the Reverend Jonathan Burr c. 1797. It provided high school and college preparation and was granted a state charter in 1804, continuing until 1814. (Photograph by Marion Vuilleumier.)

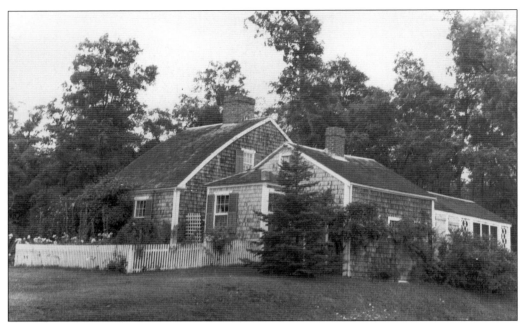

The left portion of this bow-roofed Cape Cod quarter house (one door and one window) dates to 1630. It was built originally in South Sandwich as a three-quarter house. Martha Hoxie inherited the house and had it cut and moved to Route 6A and Quaker Meeting Road for a friend. In recent years, the Cape house was moved up a hill and a new section was added. (Courtesy Sandwich Town Archives.)

This typical example of a half Cape house, on Sandy Neck Road, has a door and two windows on one side. (Courtesy Sandwich Town Archives.)

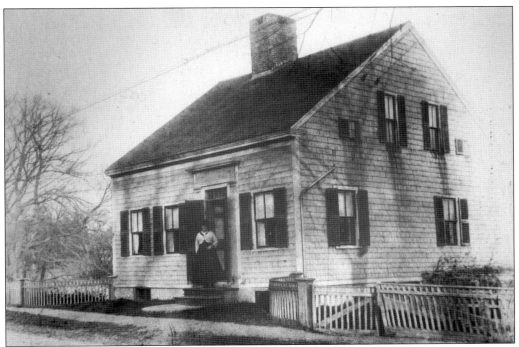

A three-quarter Cape house, such as this one on Grove Street, has a window on one side and two on the other. (Courtesy Sandwich Town Archives.)

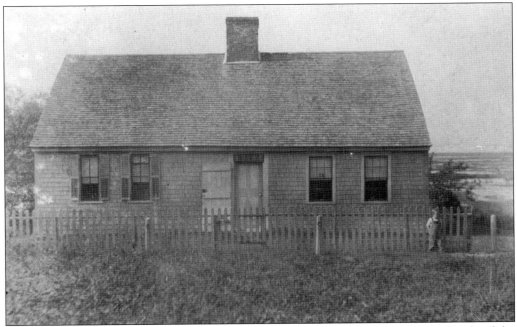

This example of a full Cape house, on Spring Hill Road, has two windows on each side of the door. (Courtesy Sandwich Town Archives.)

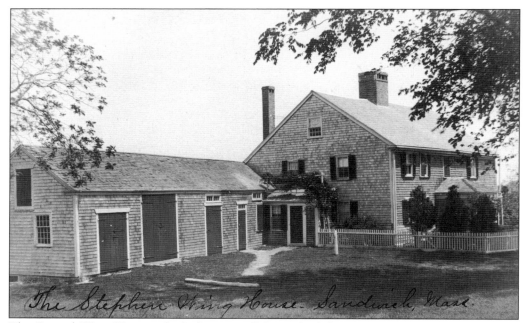

The Stephen Wing House - Sandwich, Mass.

The Samuel Wing House, which dates to 1696, was built by Asa Wing. Samuel Wing had a workshop in the left section. On the opposite side, in an adjacent building, he operated the S. Wing and Brothers Looming Company. The central portion now serves as offices for the Heritage Plantation. (Courtesy Sandwich Historical Society Archives.)

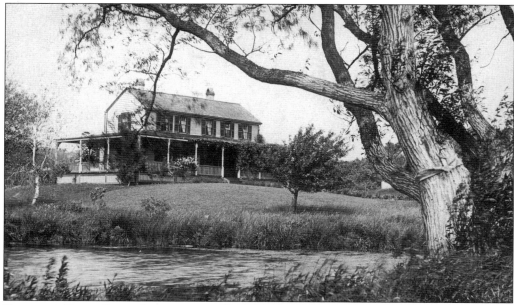

Known as Green Briar, this was originally a farmhouse, enlarged in 1840. Ida Putnam then inherited it and began a jam kitchen in 1903. Today, it is a nature center, as well as headquarters of the Thornton W. Burgess Society. (Courtesy Sandwich Town Archives.)

Two

THE INDUSTRIAL
REVOLUTION ARRIVES

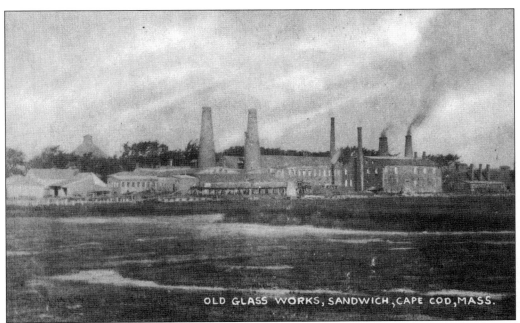

OLD GLASS WORKS, SANDWICH, CAPE COD, MASS.

Little did residents realize when they sold lots to a Boston agent that the Industrial Revolution was to arrive in Sandwich with the establishment of the Boston & Sandwich Glass Company factory, seen here in operation. Very quickly, the economy changed from an agricultural to an industrial society, and many locals began receiving a steady paycheck instead of occasionally selling their products. (Sandwich Historical Society Archives.)

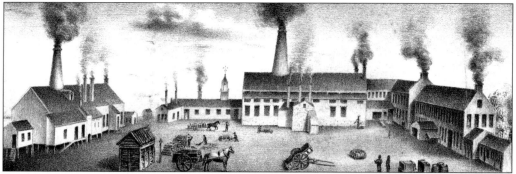

This southeast view of the Boston & Sandwich Glass Company was done by Pendleton Lithographers of Boston. (Courtesy Sandwich Historical Society Archives.)

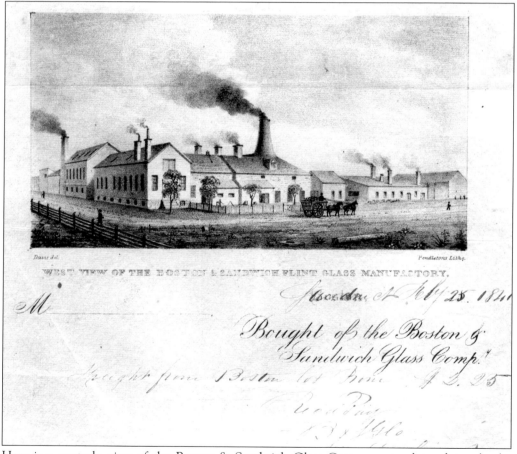

Here is a westerly view of the Boston & Sandwich Glass Company at a later date, also by Pendleton Lithographers. The lithographers refer to the company as a "Flint Glass Manufactory." (Courtesy Sandwich Historical Society Archives.)

This long structure on Factory Street was a portion of some of the company's several buildings. (Courtesy Sandwich Historical Society Archives.)

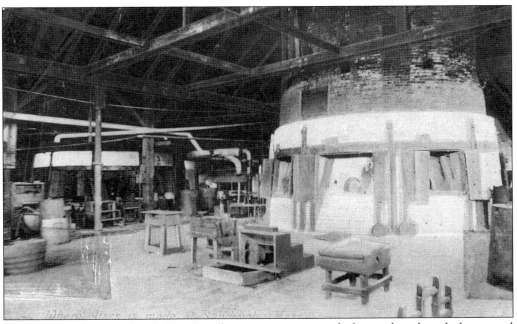

An interior photograph of the glass factory on a postcard shows the glory hole central smokestack (furnace). This is what it would have looked like in the 1880s. (Courtesy Sandwich Historical Society Archives.)

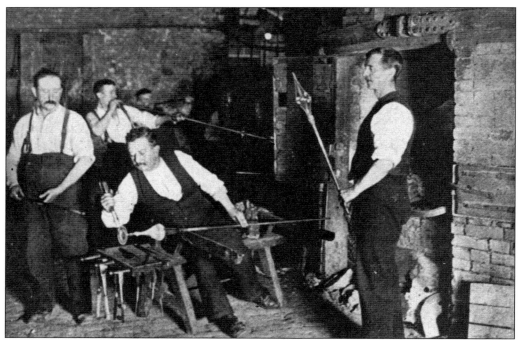

Bob Mathews is seated at the gaffer's chair, shaping a foot on a goblet. He worked at the factory in the 1880s. (Courtesy Sandwich Historical Society Archives.)

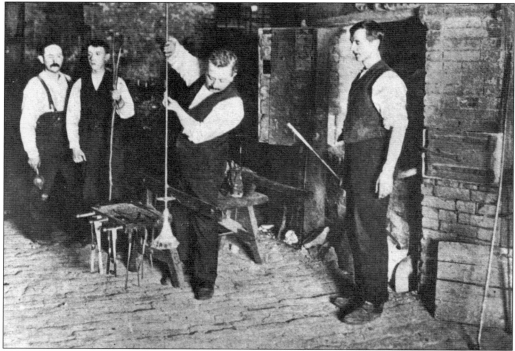

Gaffer Bob Mathews is shown here standing by the chair with the finished goblet at the end of his pontil rod. (Courtesy Sandwich Historical Society Archives.)

John Jones is pictured here marking a water bottle for cutting. Jones was a glass cutter at the factory from 1870 to 1888. (Courtesy Sandwich Historical Society Archives.)

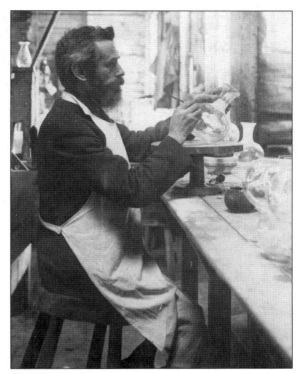

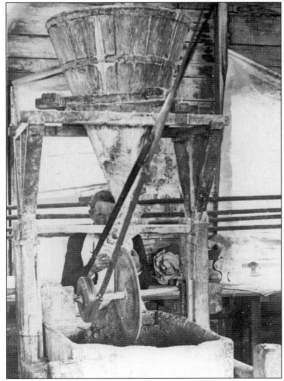

Benjamin Irwin is roughing a design onto a blank, a step in cutting. Irwin was employed at the factory from 1859 to 1888. (Courtesy Sandwich Historical Society Archives.)

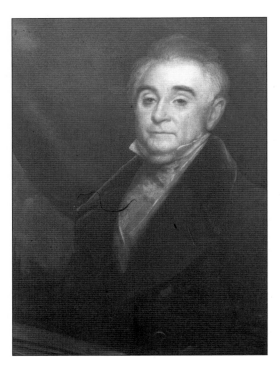

Deming Jarvis, son of a glass manufacturer, established the Sandwich firm with inherited money. Starting with blown glass, he eventually discovered how to make more inexpensive pressed glass for the middle class, since blown glass was very expensive. (Courtesy Sandwich Historical Society Archives.)

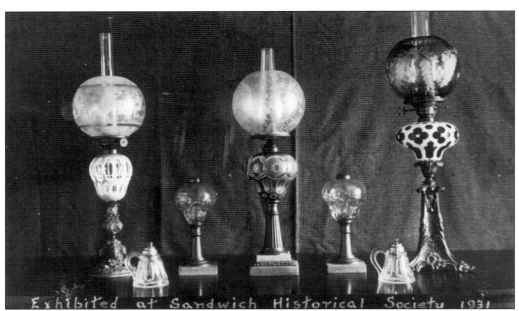

Exhibited at Sandwich Historical Society 1931

This postcard displays seven lamps made at the Boston & Sandwich Glass Company. These were on exhibit at the Sandwich Historical Society in 1931. (Courtesy Sandwich Historical Society Archives.)

This 1849 illustration of early glass pressing is from Apsley Pellott's *Curiosities of Glassmaking,* published in London. When Jarves succeeded in creating pressed glass, the glassblowers feared it would cost them their jobs, but Jarves continued with both ways of manufacturing, allaying their fears. (Courtesy Sandwich Historical Society Archives.)

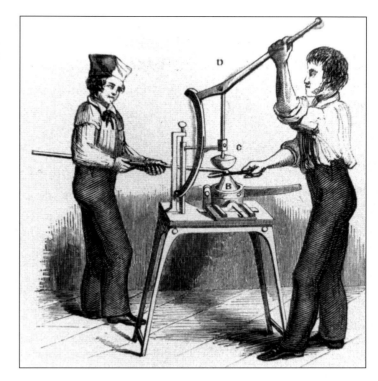

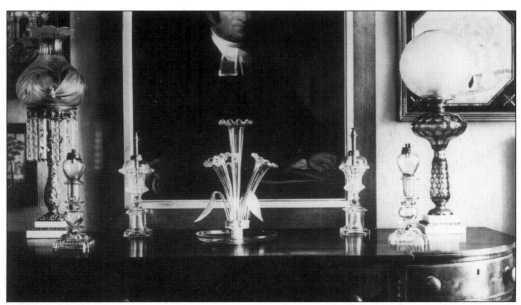

A variety of blown glass—six lamps and an epergne—is displayed in 1931. A Frederick Freeman painting and mourning embroideries hang on the wall behind. (Courtesy Sandwich Historical Society Archives.)

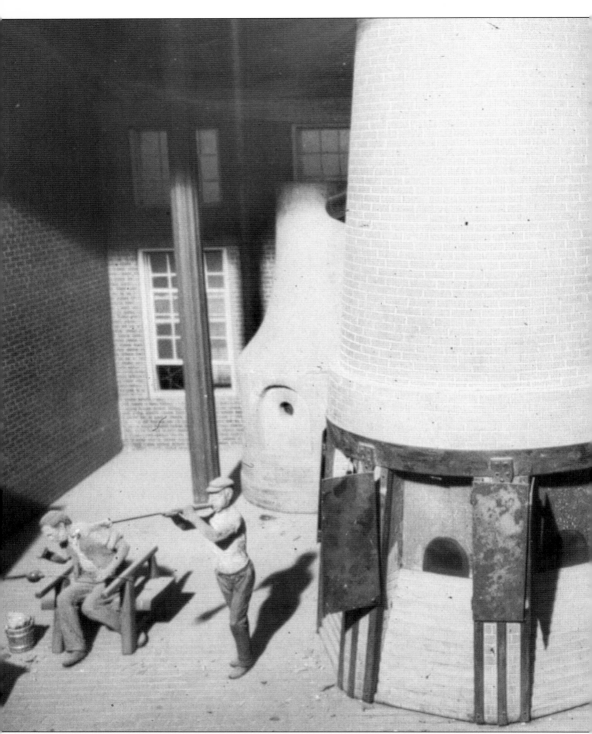

A diorama depicts the activity of the glassworks at its height. Today, 14 galleries display a great variety of products, including those produced by glassblowers and others made by pressing glass

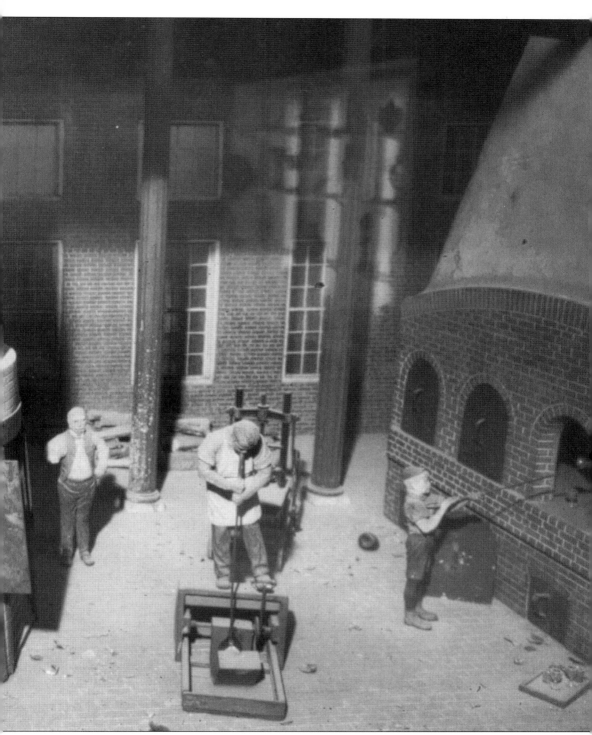

in molds. (Courtesy Sandwich Historical Society Archives.)

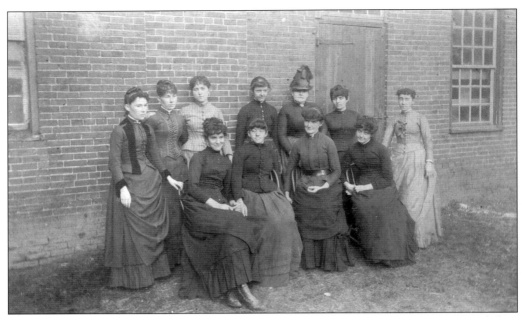

When the glass factory was operating, these ladies performed the glass decoration. From left to right are the following: (front row) Nell Kelleher, Mary Swann, Mary Kelleher, and Mame Dillaway; (back row) Ann Chamberlain, Lina Chamberlain, Bell Turpey, Ninna Fuller, Nell Bradley, Mag Bradley, and Bessie Skiffe. (Courtesy Sandwich Historical Society Archives.)

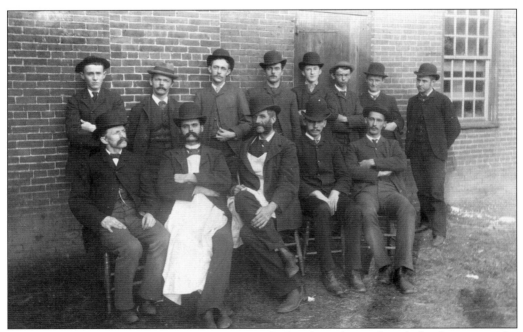

Of these men in the decorating department, only four have been identified. They are in the front row, from left to right: Thomas Fogarty, Edmund Chipman, Edward Swann, and Charles Wright. (Courtesy Sandwich Historical Society Archives.)

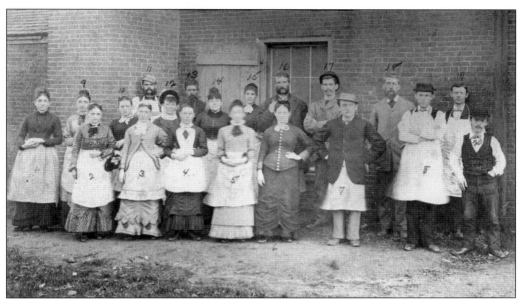

Here, men and women of the decorating department are pictured in an 1878 print. None are identified, but it is interesting to note that women are on the left and men on the right. (Courtesy Sandwich Historical Society Archives.)

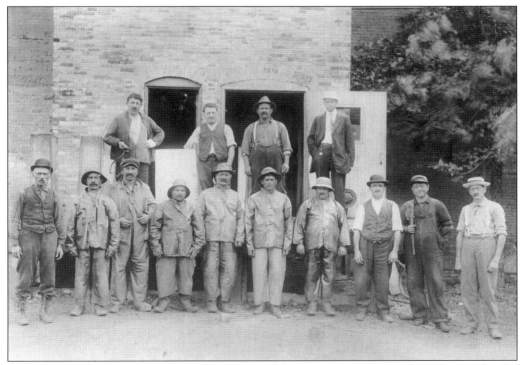

After the glass manufacturing ceased in 1888, a fish freezer plant operated in what used to be the brick pothouse. These men, who are unidentified, pose outside the brick plant. (Courtesy Sandwich Historical Society Archives.)

The fisherman's house and boats are on Town Neck marsh. (Courtesy Sandwich Historical Society Archives.)

The fish house on the marsh, at left, was owned by Eugene Haines. The house on the right belonged to cousins of Miss Spurr: Dr. Leonard Jones, Isaiah Tobey Jones Jr., Frank L. Jones, and Louis B. Jones. (Courtesy Sandwich Historical Society Archives.)

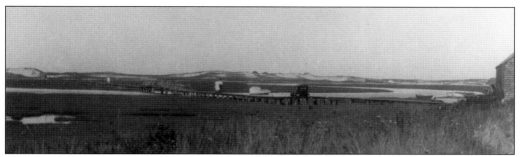

In this view, boats are seen near the footbridge over Mill Creek. (Courtesy Sandwich Town Archives.)

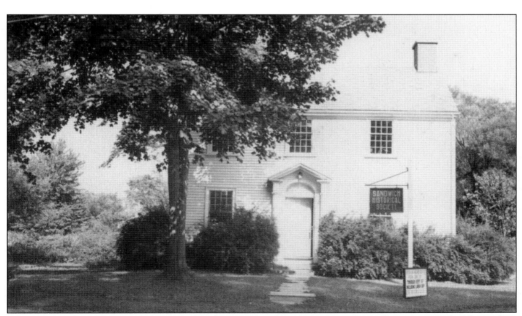

This is the first home of the Sandwich Historical Society, purchased in 1924. The first glass exhibit was in 1925, the centennial of the opening of the Boston & Sandwich Glass Company. (Courtesy Sandwich Historical Society Archives.)

When many Catholics came to work in Deming Jarves's new glass factory in 1830, a wooden chapel was built. Soon, it was overcrowded, and St. Peter's Church was erected in 1851. This Corpus Christi church was built in 1901, serving until recently, when a new parish center was established on Quaker Meeting Road. (Sketch by Pierre D. Vuilleumier.)

Episcopal churches (Anglican) were in Boston during the pre-Revolutionary era, but after the Revolution were not fully accepted until after the War of 1812. St. John's Episcopal Church, pictured here, was built in 1899. (Sketch by Pierre D. Vuilleumier.)

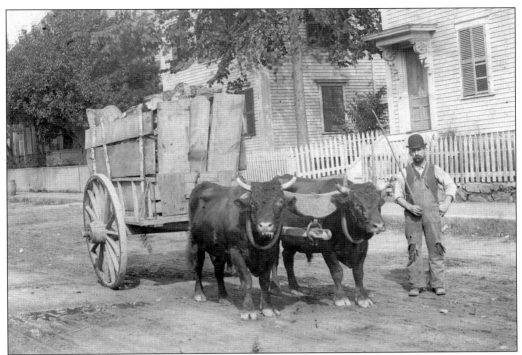

This bull wagon loaded with firewood is pictured on Jarves Street c. 1870. The driver is unidentified. (Courtesy Sandwich Historical Society Archives.)

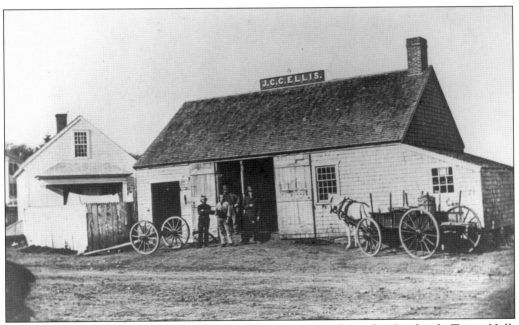

The Ellis Blacksmith shop was in the town center, across from the Sandwich Town Hall. (Courtesy Sandwich Town Archives.)

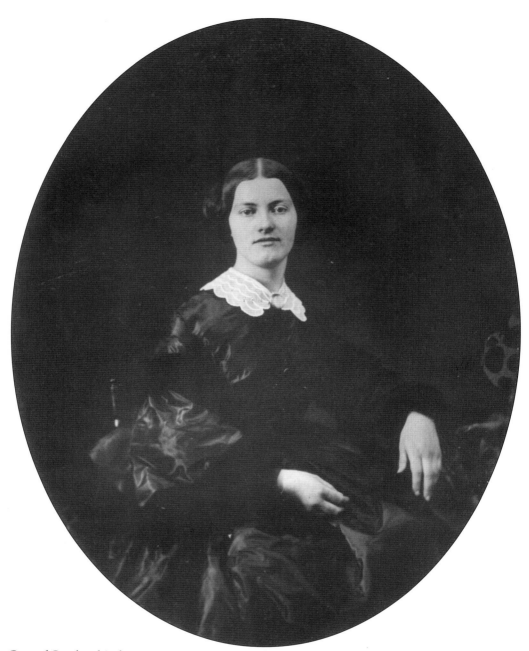

One of Sandwich's famous women was Hannah Rebecca Burgess, who at age 22 navigated a fully rigged clipper ship in the Pacific to safety in Valpariso, Chili. Having learned navigation from her husband, she was able to bring the *Challenger* safely to port, when her husband was taken ill. (Courtesy Sandwich Historical Society Archives.)

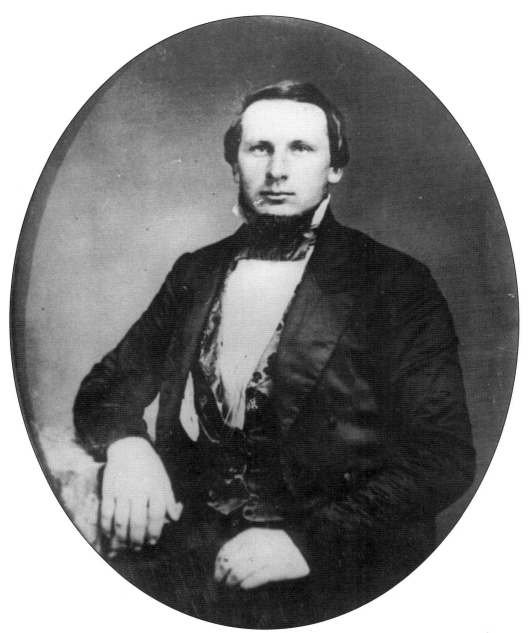

This picture of Capt. William Howes Burgess, a Brewster native, was taken in 1855, when at age 26 he became master of the clipper *Challenger*. The photographs are from *The Challenge of Hannah Rebecca*, by Martha Hassell. Rebecca's diaries are in the collection of the Sandwich Glass Museum. (Courtesy Sandwich Historical Society Archives.)

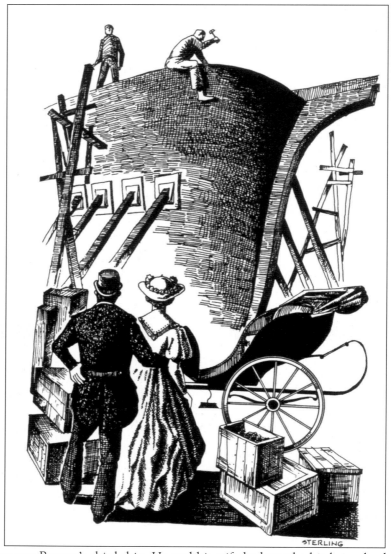

STERLING

The *Challenger* was Burgess's third ship. He and his wife had watched it being loaded for the voyage, as in this Jan Sterling illustration. In 1856, while Hannah Rebecca was with him on a Pacific voyage, he was gravely ill and died two days before reaching Valparaiso. (Courtesy Sandwich Historical Society Archives.)

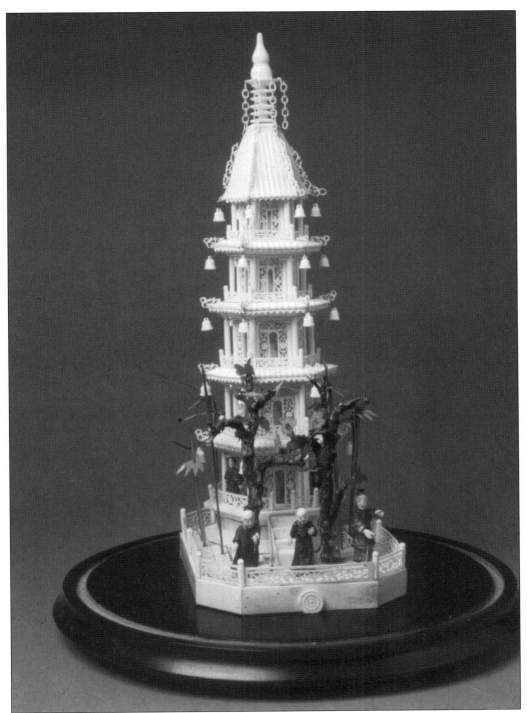

Hannah Rebecca had accompanied William Burgess on an earlier trip to China and purchased this intricately carved pagoda, one of many souvenirs she brought home from her travels. (Courtesy Sandwich Historical Society Archives.)

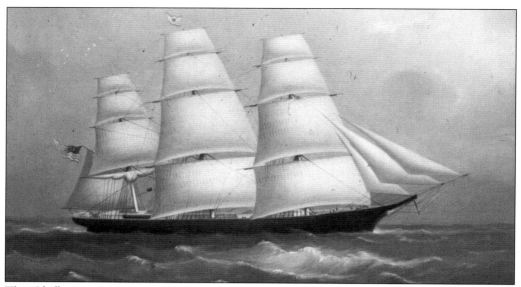

The *Challenger,* an "extreme" clipper ship, was owned by W. and F.H. Whittimore. It was launched in December 1853. The painting was made in China. (Courtesy Sandwich Historical Society Archives.)

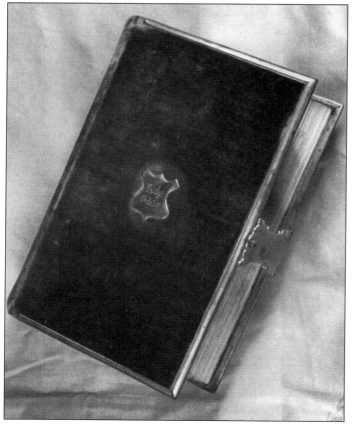

Rebecca carried this velvet-bound Bible with her on the fatal voyage. The ship's steward David Graves was so kind to her at William Burgess's death that she gave it to him. He lost it in a shipwreck in 1862, and it was found in the abandoned ship by another seaman who saw the inscription. He sent it to author Richard Dana in Boston, who located Rebecca and returned the Bible in 1864. It is in the Burgess Collection at the Sandwich Glass Museum. (Courtesy Sandwich Historical Society Archives.)

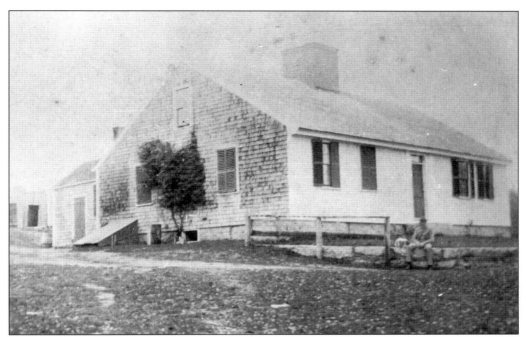

This typical full Cape house is an example of many that have added structures behind it. (Courtesy Sandwich Town Archives.)

Peter's Pond, one of the many small bodies of water in Sandwich, is shown with the smoke from a forest fire in the distance. (Courtesy Sandwich Town Archives.)

An typical family female group of about a century ago gives an example of the dress of yesteryear. (Courtesy Sandwich Town Archives.)

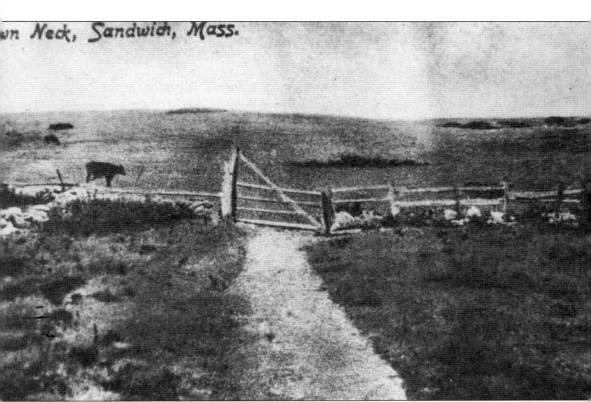

In this postcard copy, a lone cow is shown on Town Neck, where many more animals were once pastured. (Courtesy Sandwich Town Archives.)

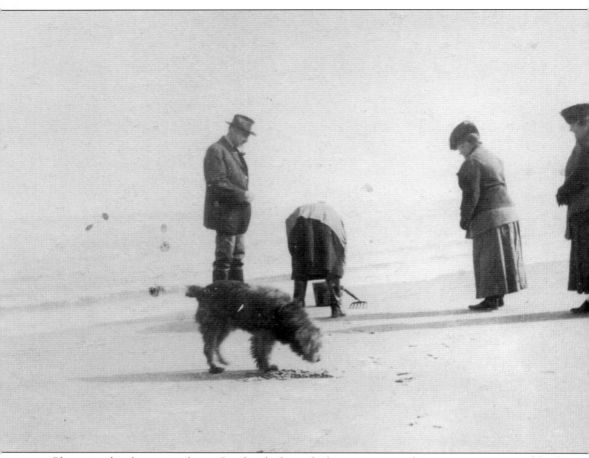

Clamming has been popular in Sandwich through the centuries and was a major source of food in the early years. (Courtesy Sandwich Town Archives.)

Three
A FACTORY
TOWN DIVIDES

This view of the Wing farm and the tack factory, at the right, shows the church steeples of the town of Sandwich in the distance. (Courtesy Sandwich Town Archives.)

This close-up of the tag factory shows the Congregational church steeple in the background. (Courtesy Sandwich Historical Society Archives.)

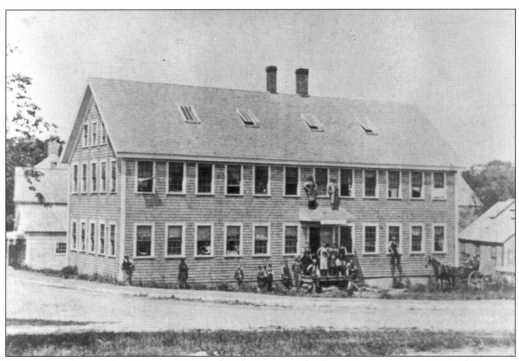

This view shows the Boston & Sandwich Boot and Shoe Company *c.* 1880. (Courtesy Sandwich Town Archives.)

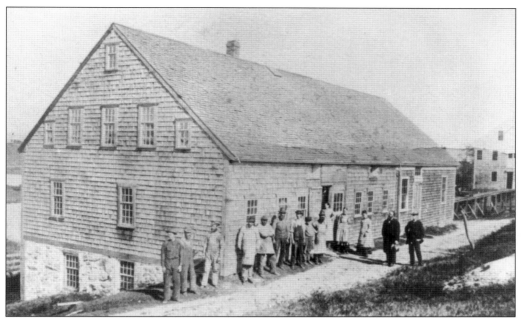

This Sandwich Tack Company, located on Grove Street, was started by Isaiah T. Jones and Henry H. Heald in 1863. It was destroyed by fire in 1883. The building on the right was a tack factory begun earlier by Stephen Rogers and S.R. Wing. (Courtesy Sandwich Town Archives.)

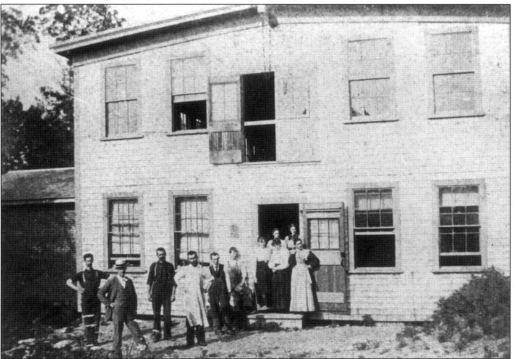

The workers of the Union Braiding Company are pictured on a break. (Courtesy Sandwich Town Archives.)

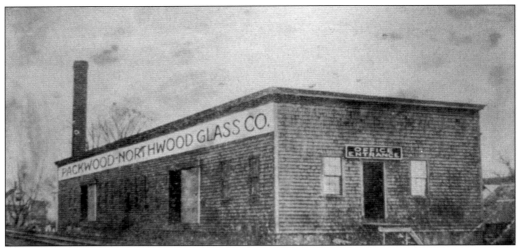

The Packwood-Northwood Glass Company is seen here in operation with smoke coming from the chimney. (Courtesy Sandwich Town Archives.)

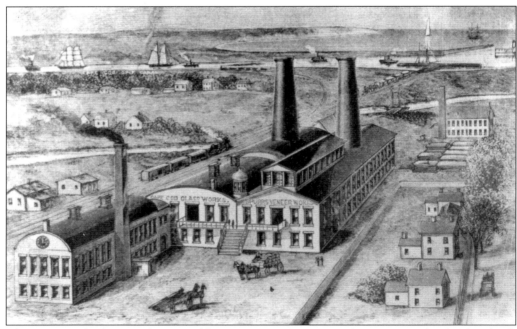

The Cape Cod Glass Works, started by Jarves in 1858, was used intermittently after his death in 1869. It absorbed some of the glassworkers at the original firm for a time. The future canal is shown in artistic license because the Lockwood Dredge was already at work. (Courtesy Sandwich Town Archives.)

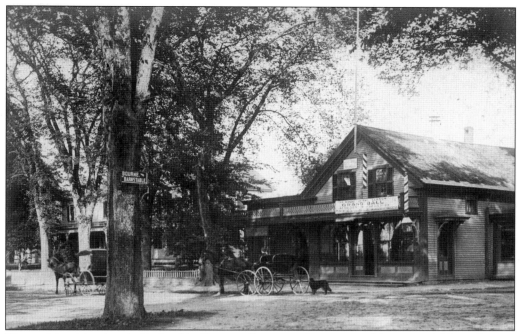

Pictured in this view is Burbank's Grocery Store, at the corner of Jarves and Main Streets, with the transportation of the day, horse and carriage. (Courtesy Sandwich Historical Society Archives.)

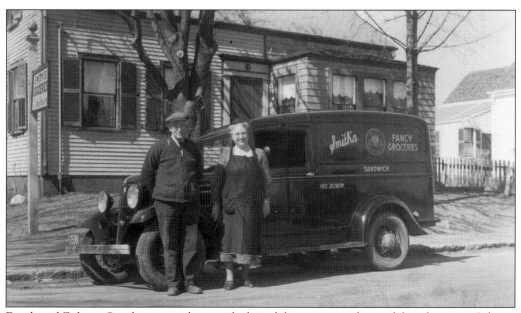

Frank and Zuleme Smith are seen here with their delivery van in front of their home on Liberty Street. (Courtesy Barbara Gill.)

Isaac Keith and his partner Mr. Ryder, who was a blacksmith, produced Conestoga wagons, oxcarts, and sleighs in the early 1800s. When the railroad arrived in 1848, they also produced small cars to carry sand or coal. At the time, their factory was still part of Sandwich. (Courtesy Cape Cod Community College Archives.)

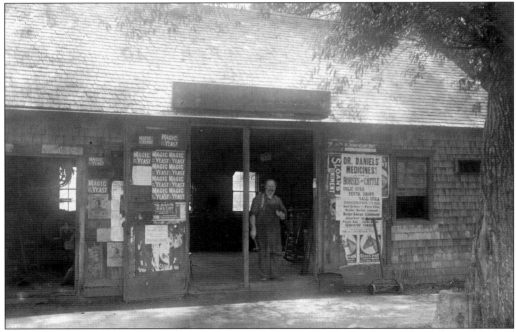

A blacksmith shop on Jarves Street is shown with proprietor Mr. Sullivan holding some tools. (Courtesy Sandwich Historical Society Archives.)

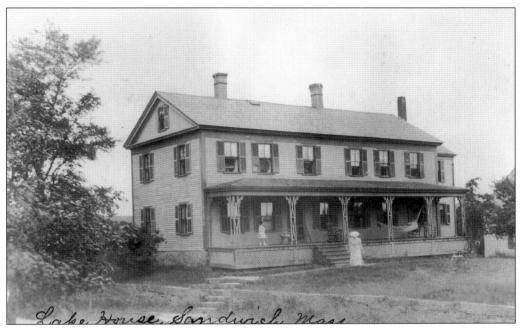

The Lake House on Water Street, the former Sandwich Academy, was a boardinghouse. (Courtesy Barbara Gill.)

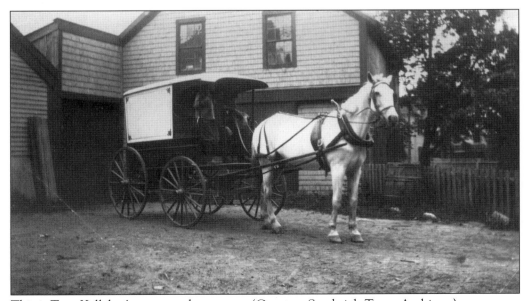

This is Tom Kelleher's meat-market wagon. (Courtesy Sandwich Town Archives.)

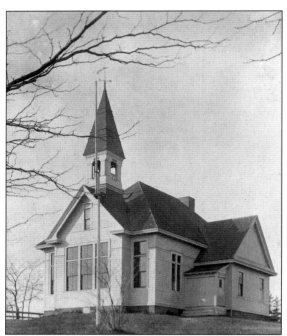

Sandwich High School, on Academy Road, was built in 1881. (Courtesy Sandwich Historical Society Archives.)

In the early 1800s, a church was built in Forestdale on Route 130 by the Methodists. Preacher's fees were $2 a Sunday! Later, the church became Baptist. The small church was surrounded by graves. In 1953, therefore, it was moved across the road and enlarged. The original Forestdale schoolhouse, which stood on the same side, is still on its original site. (Sketch by Pierre D. Vuilleumier.)

Abolitionists were active in Sandwich. One group was the Wide-Awake Club, whose members are shown in procession on Factory Street in 1860. This print is from the 1888 book *Abraham Lincoln,* by Noah Brooks. (Courtesy Sandwich Historical Society Archives.)

Shawme Pond is pictured here in a view from Water Street. A boathouse is on the right. (Courtesy Sandwich Historical Society Archives.)

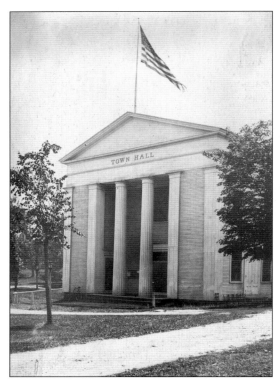

State law now prohibited any connection between religious societies and town government, so it was no longer possible to hold a town meeting in a church building. Thus, the Sandwich Town Hall was completed in 1834, and the first town meeting held was in 1835. (Courtesy Sandwich Historical Society Archives.)

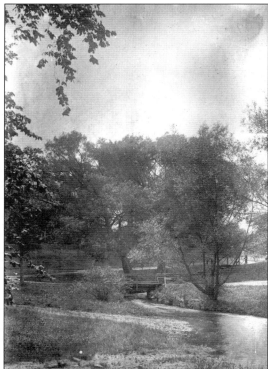

This walking bridge in the Sandwich Town Hall area was probably a pleasing respite during town meetings. (Courtesy Sandwich Historical Society Archives.)

The cemetery on Grove Street provides a view in the winter of Shawme Pond and the Hoxie House. (Courtesy Cape Cod Community College Archives.)

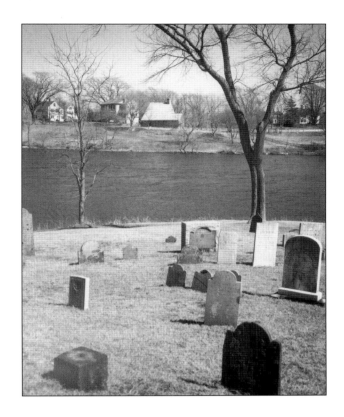

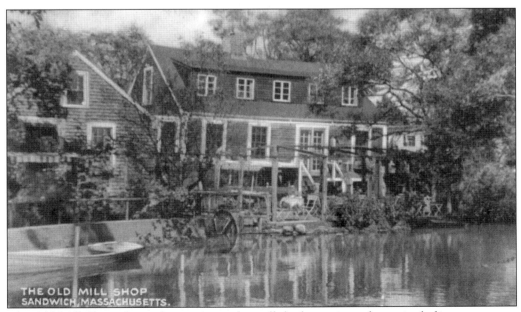

The Old Mill Shop, shown here next to the mill, had a variety of uses, including a tearoom, before being eventually torn down. (Courtesy Barbara Gill.)

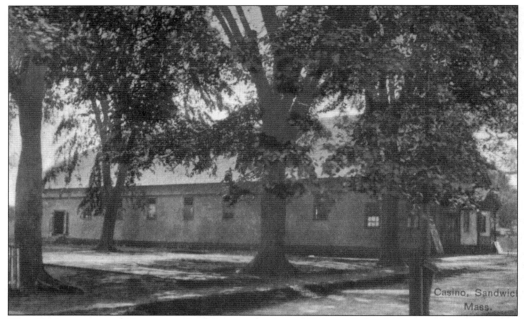

The Casino was an all-purpose building erected in 1884 on School Street. Dances, roller-skating parties, and other social events were held here. (Courtesy Sandwich Historical Society Archives.)

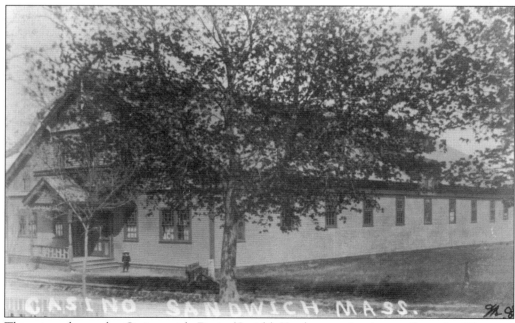

This view shows the Casino with Doris (Smith) Kershaw posing in a sailor suit. (Courtesy Barbara Gill.)

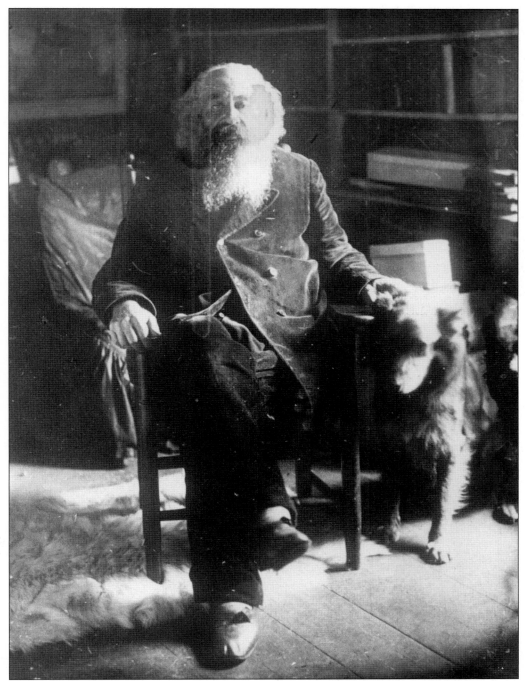

Nathan Henry Chamberlayne, a Unitarian minister born in Monument Beach in 1828, was one of the town's first authors. He wrote three books, including *Autobiography of a New England Farmhouse*, based on his upbringing in the Sandwich poorhouse operated by his father. He retired with his dog Foxy to Bourne in 1889. (From Bourne Town Archives; courtesy Cape Cod Community College Archives.)

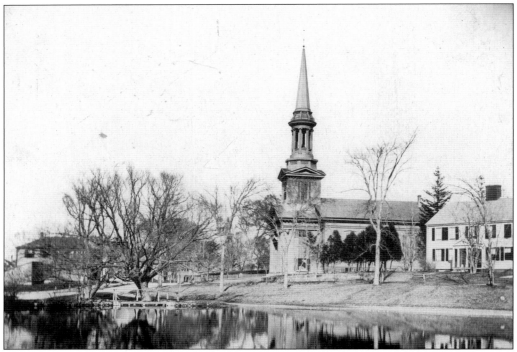

The Congregational church, with the Dunbar House to the right, is seen with their reflections in Shawme Pond. Part of the Sandwich Town Hall can be seen to the left. (Courtesy Sandwich Historical Society Archives.)

The elaborate front of the elegant Burbank House, on Main Street, is bordered by a picket fence, as seen in the 1900s. (Courtesy Sandwich Historical Society Archives.)

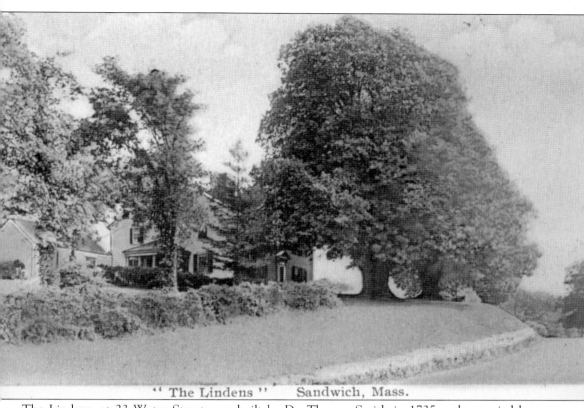

" The Lindens " Sandwich, Mass.

The Lindens, at 23 Water Street, was built by Dr. Thomas Smith in 1735 and occupied by the Reverend Jonathan Burr from 1747 to 1842. A recent owner was historian Francis Russell, who wrote 16 substantial works, including *City of Terror* about the Boston police strike. He also wrote about the Sacco-Vanzetti case. (Courtesy Barbara Gill.)

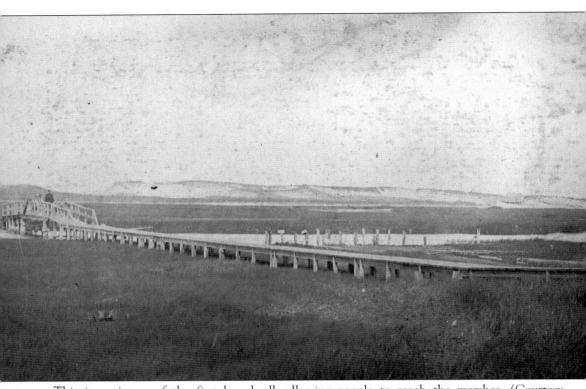

This is a picture of the first boardwalk allowing people to reach the marshes. (Courtesy Sandwich Historical Society Archives.)

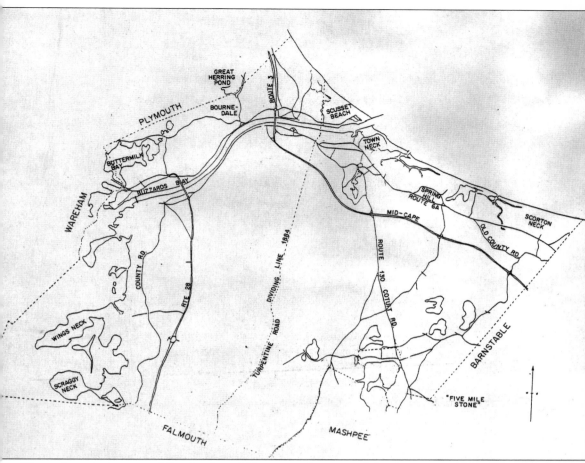

Shown here is the map of Sandwich and Bourne at the time of the division in 1884. (Sketch by Louis Vuilleumier, adapted from *Sandwich: A Cape Cod Town,* by Russell A. Lovell Jr.; courtesy Sandwich Town Archives.)

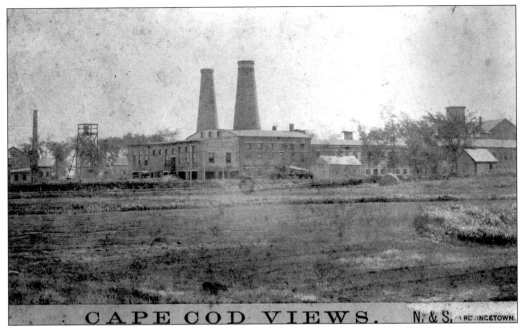

The Boston & Sandwich Glass Company is pictured here after it ceased operation in 1888. (Courtesy Sandwich Town Archives.)

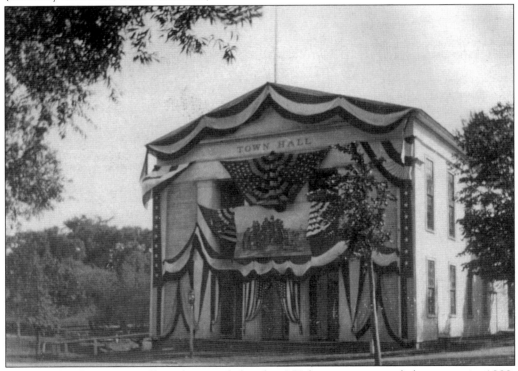

The Sandwich Town Hall is decorated for the 250th anniversary of the town in 1889. (Courtesy Sandwich Town Archives.)

Here, the First Parish Church (Unitarian) is decorated for the 250th anniversary of the town. (Courtesy Sandwich Historical Society Archives.)

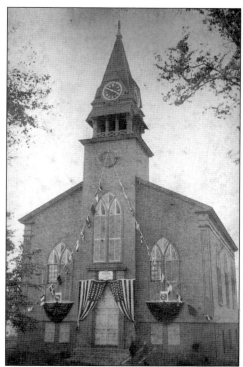

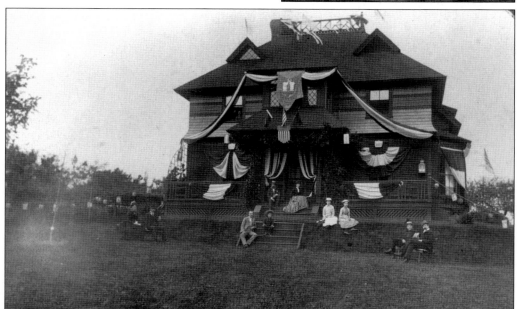

The Spurr-Belcher House, on Main Street, is decked with bunting and Chinese lanterns for the anniversary. From left to right are the following: (on left bench) Mrs. Thacher Spurr and Eliot Spurr, (on stairs) Frank Spurr and H.W. Spurr Jr., (on porch) Henry F. Spurr and Mrs. Warren Spurr, (on wall) Gertrude and Estelle Spurr, (on right bench) Russell and Warren Spurr. (Courtesy Sandwich Town Archives.)

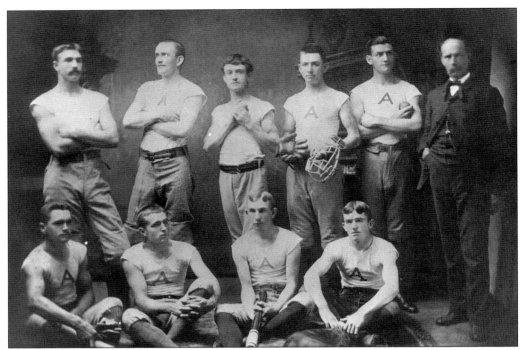

Seen in this view is the 1888 Sandwich baseball team with the team's equipment and coach. (Courtesy Sandwich Town Archives.)

Robert A. Hammond owned this house in the mid-1800s. A man of many projects, he for a time operated the fish freezer plant in part of the old glassworks. The house is now part of the Riverview School. (Courtesy Sandwich Town Archives.)

Four
CHANGES ACCELERATE

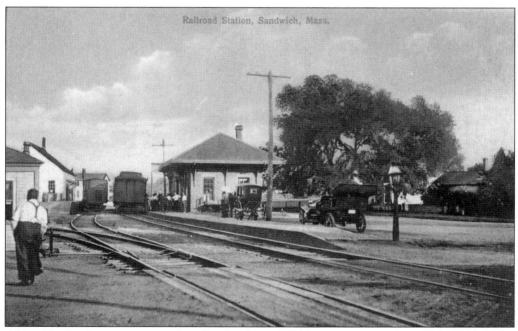

Although the first train arrived in Sandwich in 1884, it was not until much later that the volume of goods rose and the rails reached throughout the Cape, all chugging noisily through town. Here, the Sandwich Depot shows the transition from the horse-and-buggy years to the automobile. (Courtesy Sandwich Town Archives.)

Hugh Brady stands ready for business at the Liberty Street railroad crossing. (Courtesy Sandwich Town Archives.)

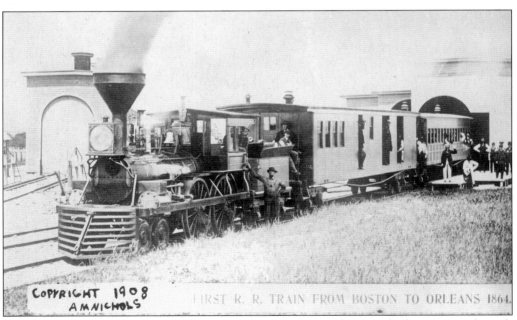

COPYRIGHT 1908
A M NICHOLS

FIRST R. R. TRAIN FROM BOSTON TO ORLEANS 1864.

The first railway train to travel from Boston to Orleans of course had to steam through Sandwich. (Courtesy Sandwich Historical Society Archives.)

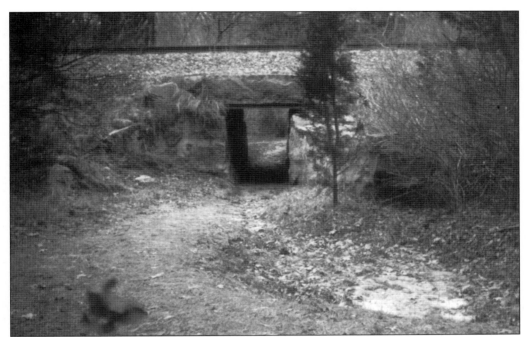

When settlement came to Sandwich, not only were the herring blocked from their home ponds and fish ladders had to be built but, later, cows were blocked from their pastures by railroad tracks. They, too, had to be accommodated, so special underpasses like this one off Old County Road were created. (Courtesy Sandwich Town Archives.)

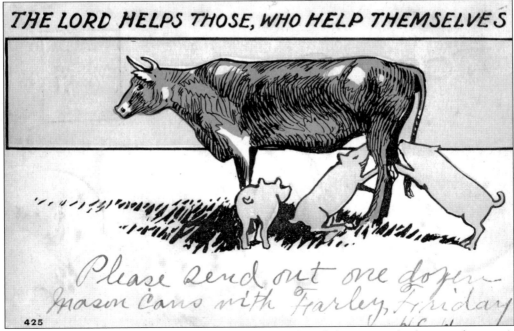

THE LORD HELPS THOSE, WHO HELP THEMSELVES

Please send out one dozen
mason cans with Farley, Friday

Postcards with humor were often sent from Cape Cod, and this postcard relates to this page's theme. (Courtesy Barbara Gill.)

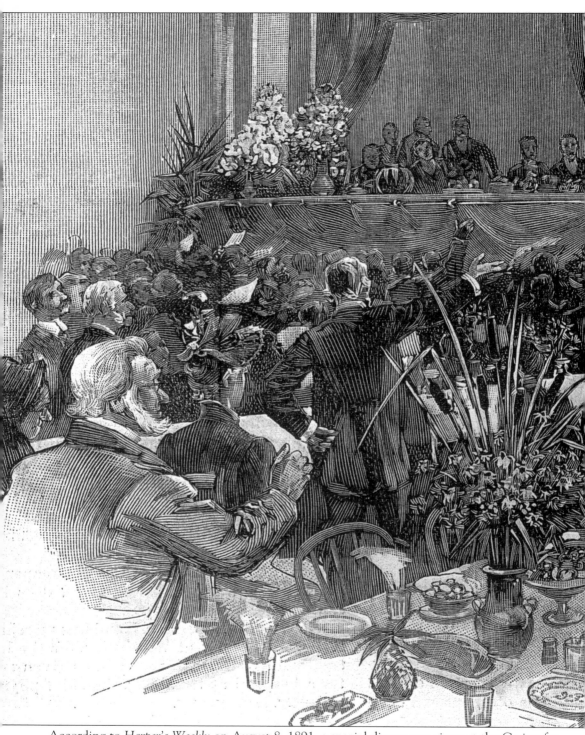

According to *Harper's Weekly* on August 8, 1891, a special dinner was given at the Casino for
ex-president Grover Cleveland, a "neighbor" who often spent time at Gray Gables, his summer

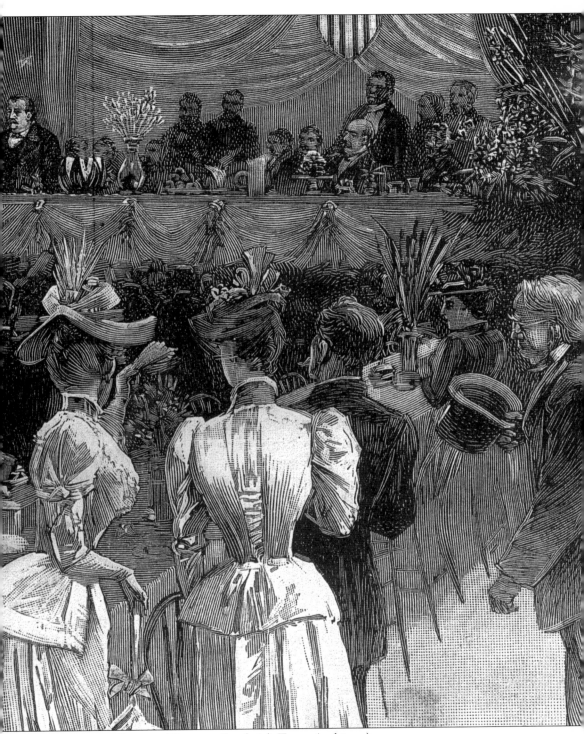

White House in Bourne. (Courtesy Sandwich Town Archives.)

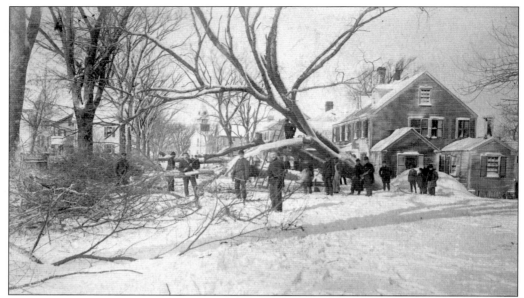

A terrible gale Thanksgiving weekend in 1898 wreaked havoc on Cape Cod and sank the steamer *Portland* with great loss of life. Sandwich's Main Street was greatly damaged. Here, about 15 people are out to assess the losses. (Courtesy Sandwich Historical Society Archives.)

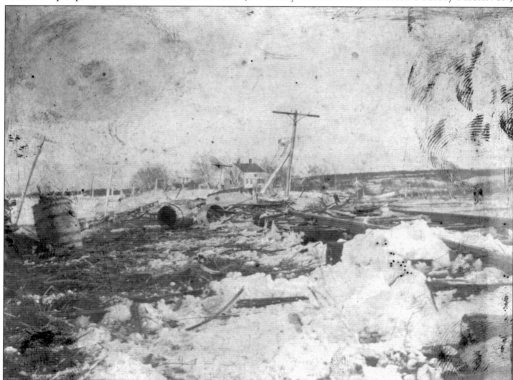

The railroad tracks one-quarter mile east of Sandwich were also badly damaged, and much debris was tossed around. (Courtesy Sandwich Town Archives.)

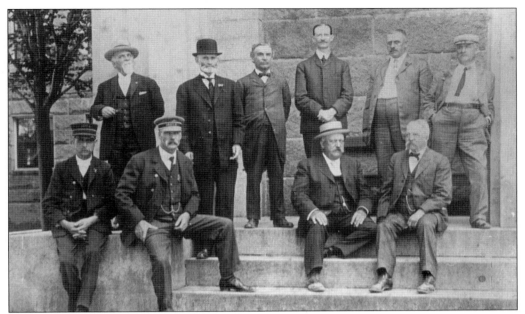

Although Sandwich governs its own affairs, residents had to travel for county business to the county courthouse in Barnstable. The officials pictured *c.* 1900 are, from left to right, as follows: (front row) a jailer; Capt. Allen Nickerson; Charles Thompson, commissioner; and Alfred Crocker, clerk of superior court; (back row) Thomas Soule, commissioner; Clarendon Freeman, register of probate; Freeman L. Lothrop, judge of probate; John A. Holway, register of deeds; Henry Percival, high sheriff; and Lafayette Chase, commissioner. (Cape Cod Community College Archives.)

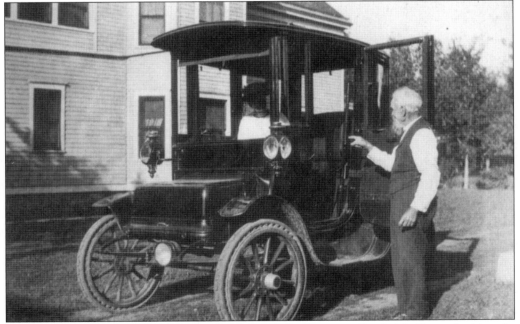

In this view, Elbridge Higgins admires his automobile. (Courtesy Sandwich Town Archives.)

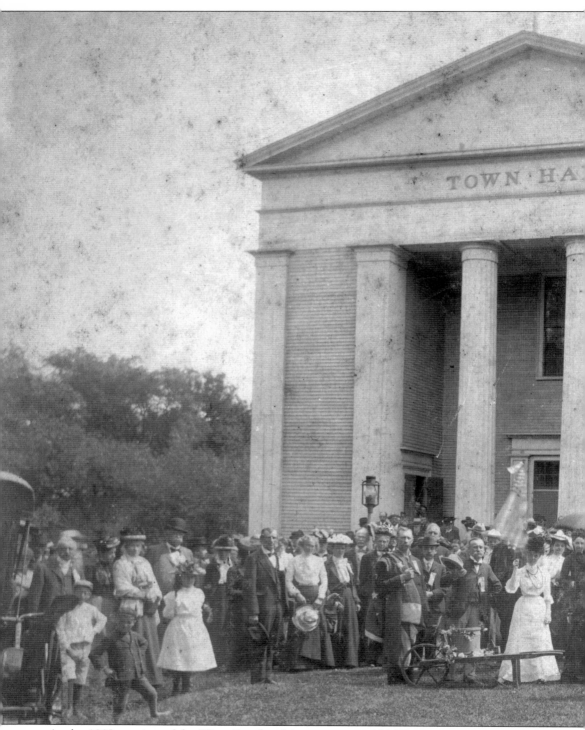

At the 1902 reunion of the Wing Family of America, some 300 Wings were present and many of them paraded to the Sandwich Town Hall to present a wooden firkin containing 30 pounds

of butter to the selectmen. This was a reminder of the scarcity of coin in 1652–1653, when their ancestors were assessed taxes in butter. (Courtesy Wing Family of America.)

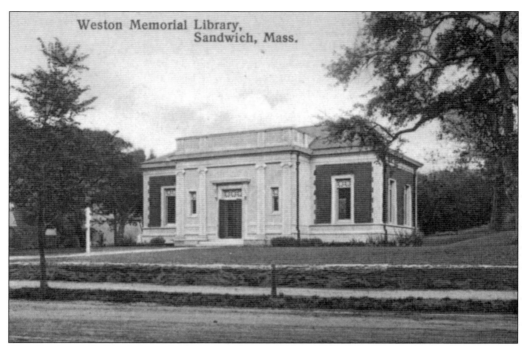

The Sandwich Public Library began on August 8, 1891, in the law office of Seth Nye. By 1910, a new $25,000 library was built on Main Street. It was named the Weston Memorial Library because of a bequest from the estate of Mr. and Mrs. H.H. Weston. In recent years, it has been substantially enlarged and is now called again the Sandwich Public Library. (Courtesy Sandwich Historical Society Archives.)

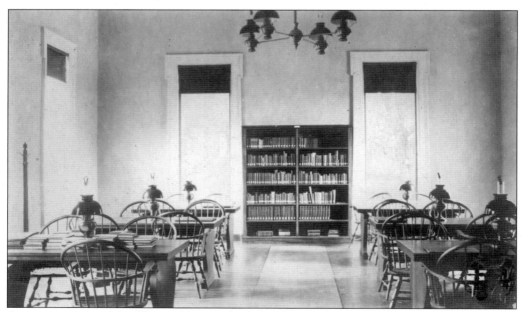

An interior view of the Weston Memorial Library shows a few books, a reading area, gas lamps, and a gas chandelier. (Courtesy Sandwich Historical Society Archives.)

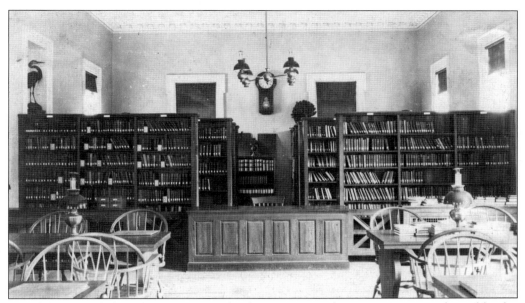

Another view of the Weston Memorial Library interior shows a greater number of books. (Courtesy Sandwich Historical Society Archives.)

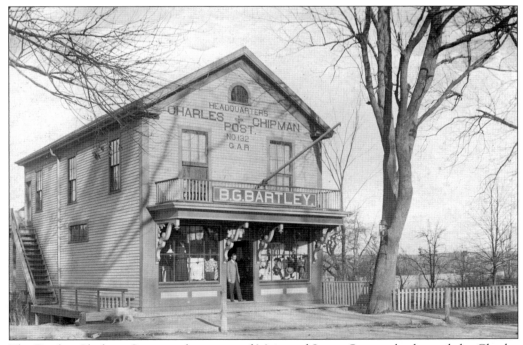

The Bartley Clothing Store, at the corner of Main and Jarves Street, also housed the Charles E. Chipman Post of the Grand Army of the Republic. (Courtesy Sandwich Historical Society Archives.)

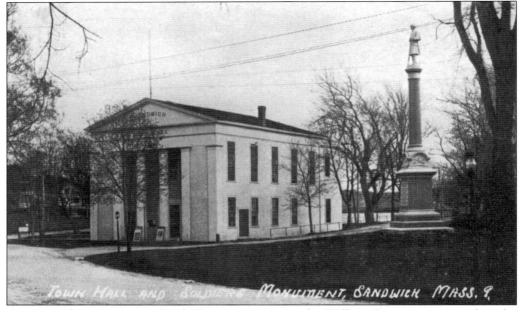

A memorial monument to Civil War veterans, given by William Eaton, was erected in the Sandwich Town Hall Square in 1910. The square was then named Eaton Square. The *Yarmouth Register* and regimental records list 40 men from Sandwich who died in the war years. (Courtesy Cape Cod Community College Archives.)

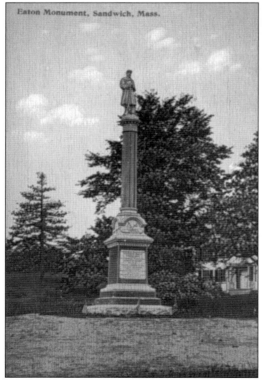

This is a close-up look at the Eaton monument. Maj. Charles Chipman (1830–1864), killed at Petersburg, Virginia, was the senior officer to die from Sandwich. An oil painting of him is in the Sandwich Glass Museum. (Courtesy Sandwich Town Archives.)

Daniel Webster (1782–1852) was a famous lawyer and orator. He served several terms in Congress and was often a visitor in Sandwich, where he hunted and fished and where a room was reserved for him in Fessenden Tavern. (Courtesy Sandwich Town Archives.)

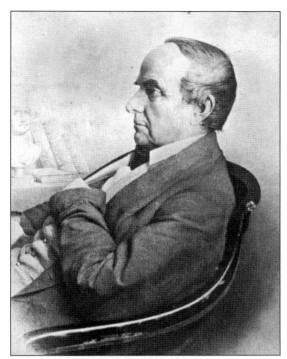

The Nye Homestead was built by Benjamin Nye in 1685. He also built a gristmill, a fulling mill, and a sawmill. From 1911 to 1959, the property was owned by the state and a fish hatchery established, and then the home was deeded to the Nye Family of America, which had begun reunions in 1903. This photograph was taken c. 1900, before the wing at the left was removed. (Courtesy John Cullity and Rosanna Cullity.)

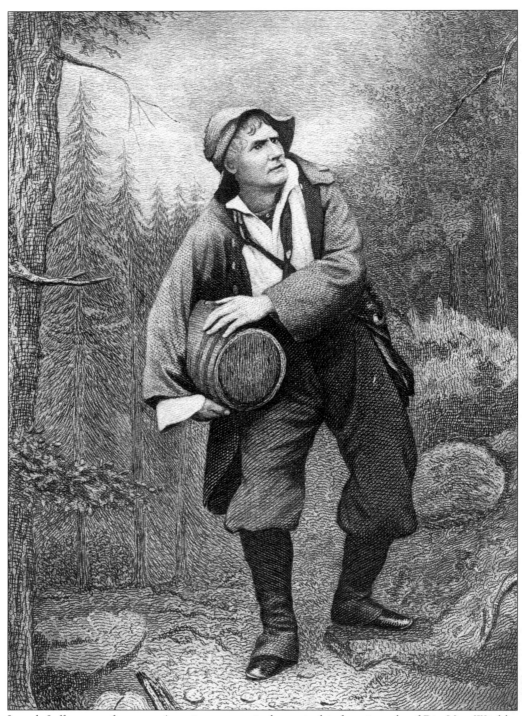

Joseph Jefferson, a foremost American actor, is shown in his favorite role of Rip Van Winkle. He summered at Buttermilk Bay and was a close friend of President Grover Cleveland. (Courtesy Sandwich Historical Society Archives.)

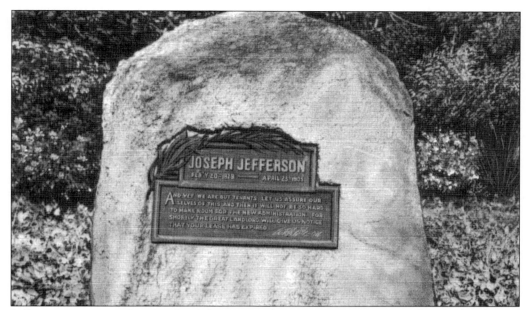

Jefferson was attracted to Sandwich but received no encouragement to settle, which is hinted at on the front of his gravestone. However, he had the last word by purchasing a cemetery plot overlooking Shawme Pond. (Courtesy Sandwich Town Archives.)

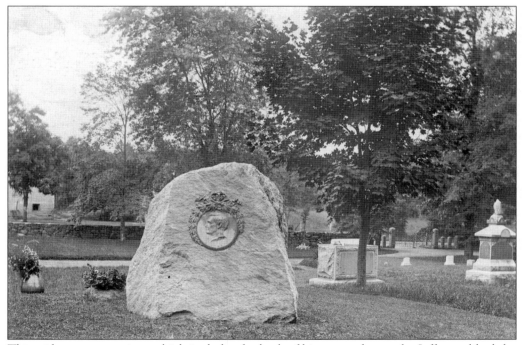

This wider cemetery view, which includes the back of his stone, shows why Jefferson liked the Sandwich ambiance. (Courtesy Sandwich Historical Society Archives.)

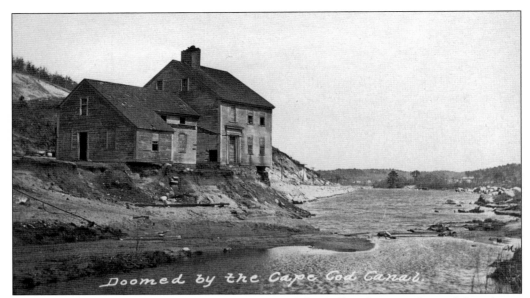

Doomed by the Cape Cod Canal.

By this time, the Cape Cod Canal was under way and the Collins farm was doomed. It is shown in this postcard abandoned and hanging off an undercut embankment. (Courtesy Sandwich Historical Society Archives.)

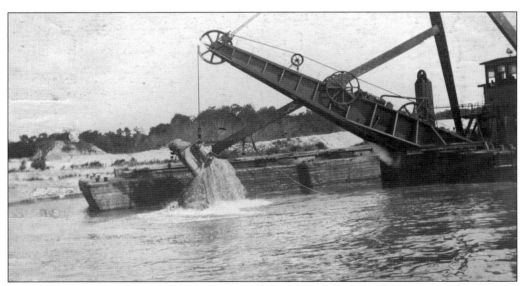

Digging continued inexorably for the Cape Cod Canal, and the last dike was cut in April 1914, in the presence of dignitaries. Financier August Belmont had succeeded where several earlier attempts had failed. (Courtesy Sandwich Historical Society Archives.)

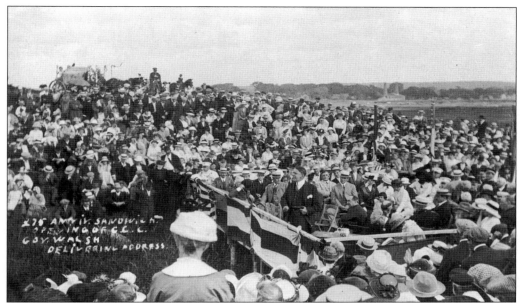

The double observance of the 275th anniversary of Sandwich and the opening of the Cape Cod Canal took place on July 29, 1914. Governor Walsh is pictured here making a speech at this dual event. The "mainland" is seen across the canal waters. (Courtesy Sandwich Historical Society Archives.)

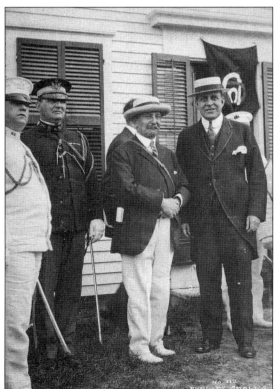

August Belmont (left) and Governor Walsh of Massachusetts shake hands at the Cape Cod Canal opening on July 29, 1914. (Courtesy Sandwich Historical Society Archives.)

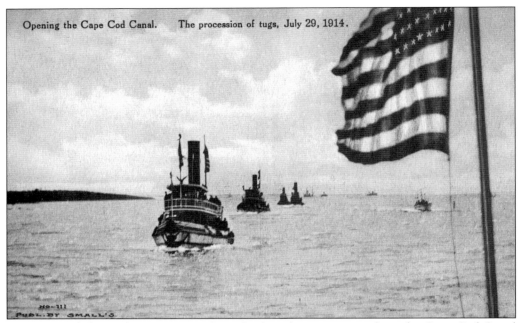

This postcard shows the procession of tugs leading the marine parade at the Cape Cod Canal opening. (Courtesy Sandwich Historical Society Archives.)

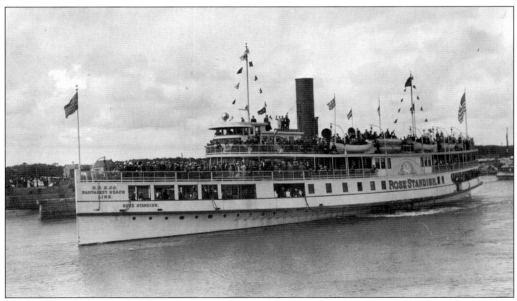

The Nantucket excursion boat *Rose Standish*, with Belmont and invited dignitaries aboard, is seen approaching Buzzards Bay in the opening parade of ships. (Courtesy Sandwich Historical Society Archives.)

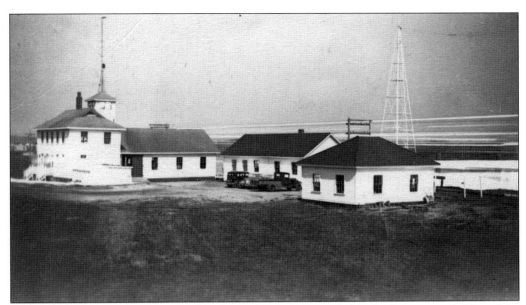

The first Sandwich Coast Guard Station is shown by moonlight on this postcard. The white streaks are from searchlights on passing ships. (Courtesy Sandwich Historical Society Archives.)

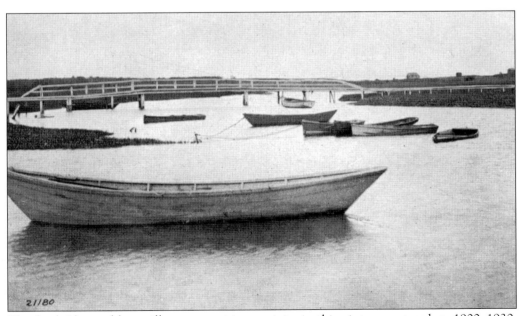

The footbridge and boats illustrate maritime activity in this vintage postcard, c. 1900–1930. (Courtesy Sandwich Historical Society Archives.)

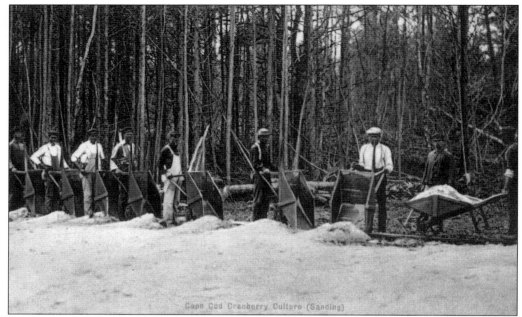

Cranberry culture flourished in Sandwich in the late 1800s. One of its least pictured activities is sanding. In this postcard, men are sanding a bog, using wedge-shaped wheelbarrows. (Courtesy Sandwich Historical Society Archives.)

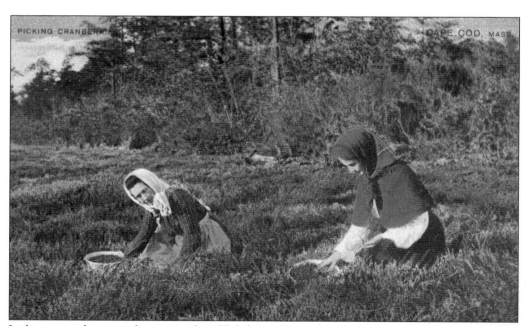

Ladies are picking cranberries in the old-fashioned way, long before machines were available. In the early years of cranberry culture, school was closed when the berries were ready, so the whole family could help harvest them. (Courtesy Sandwich Historical Society Archives.)

John H. Foster, who was born in the Skiffe House in Spring Hill in 1853, was briefly in the diamond business, founded dancing schools in European capitals, and built a palatial mansion at Spring Hill called Masthead. He entertained socially, even welcoming President Grover Cleveland. (Courtesy Sandwich Town Archives.)

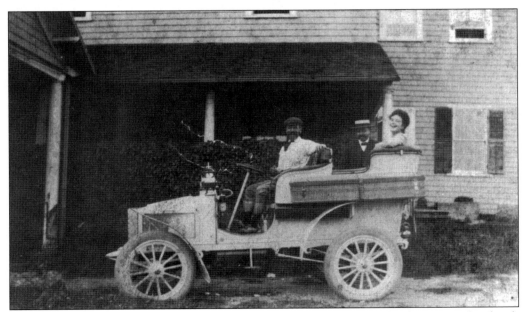

John H. Foster is in the White Steamer at Masthead with friends. (Courtesy Sandwich Town Archives.)

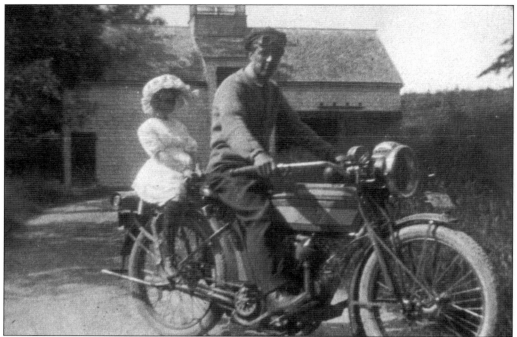

The motorcycle has now joined the varied means of transportation. Bert Tomlinson and Margaret Boston are riding it at the Faunce Demonstration Farm. (Courtesy Sandwich Town Archives.)

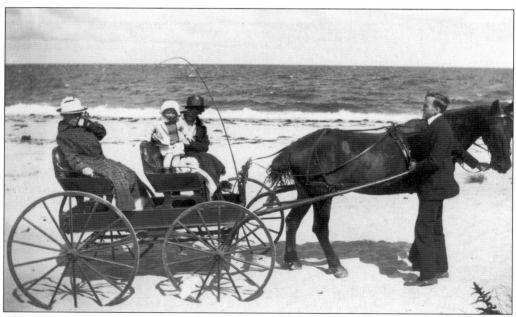

Although the motorcycle is now an option for transportation, the horse and carriage is still popular, even at the beach. These folk are members of the Freeman family out for a sandy ride. (Courtesy Sandwich Town Archives.)

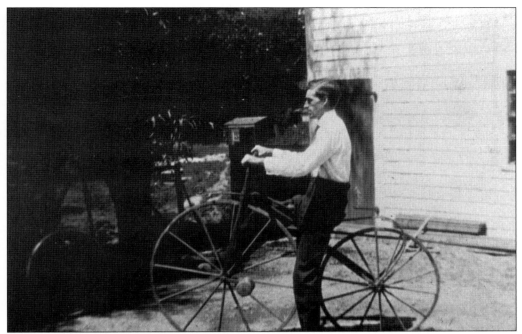

Laurence Boston is seen at the Faunce Demonstration Farm on a bicycle, another perennial form of transportation. (Courtesy Sandwich Town Archives.)

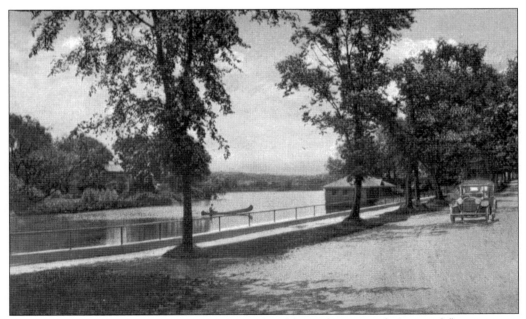

By now, the automobile is gaining momentum, heralding a future trend. A typical flivver is seen by Shawme Pond. (Cape Cod Community College Archives.)

The Everard Pratt family is enjoying a day at the beach in more formal attire than today. (Courtesy Sandwich Town Archives.)

These folks are coming in from clamming at Sandwich beach, also in more formal attire. (Courtesy Sandwich Town Archives.)

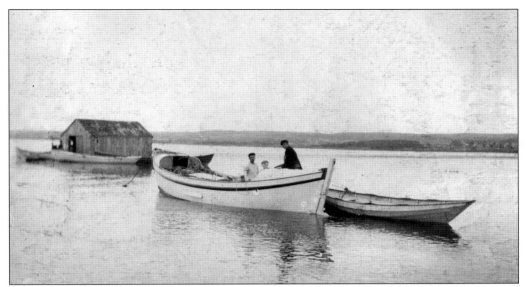

A fish house and fishermen at work are shown at Town Neck, off Marsh Avenue. (Courtesy Sandwich Historical Society Archives.)

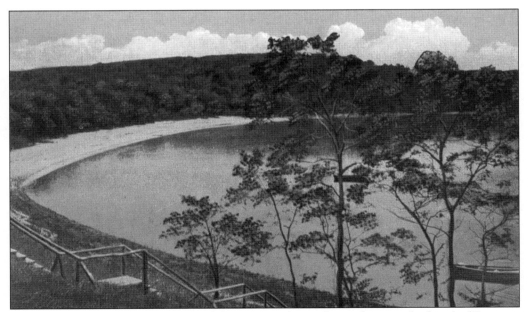

This postcard view of Spectacle Pond shows a wooden walkway down to the beach. (Courtesy Sandwich Historical Society Archives.)

Charles Henry Burgess (1815–1905) was the grandfather of Thornton W. Burgess. (Courtesy Sandwich Town Archives.)

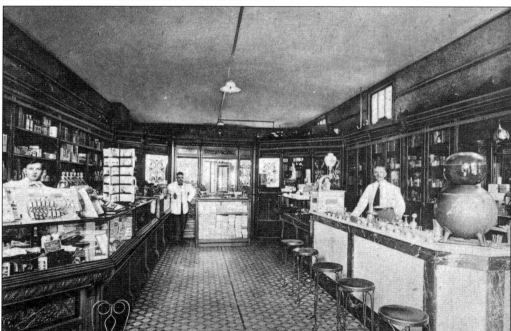

In this interior view of the Procter's Pharmacy in Sandwich, it looks as if the clerk is ready to sell ice-cream sodas! (Courtesy Cape Cod Community College Archives.)

Five

A TURBULENT CENTURY

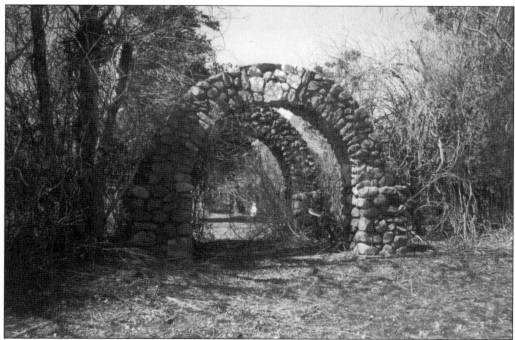

These arches on Tupper Road, near the Tupper Stone, were built by Italian resident Pedro Auriliano in the 1920s, according to historian Russell Lovell. The arches are made of stone pieces with white felspar mounted at the top. No one seems to know why he built them, so they remain a pleasant mystery in town. (Photograph by Marion Vuilleumier.)

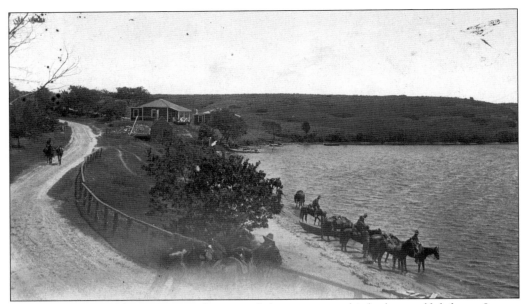

Perhaps it was troubles in Europe that caused Americans to think about self defense. In any event, just after 1900, national guardsmen were camping and training by Sandwich ponds. This postcard, sent in 1908, shows an army group watering their horses at Triangle Pond. (Courtesy Barbara Gill.)

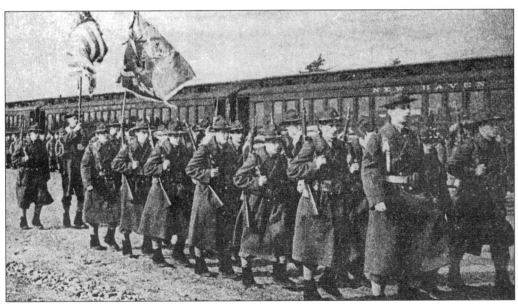

Soon, army tents were erected, and soldiers in World War I gear were seen training. When America entered the war in 1918, troops left from this area for overseas. (Courtesy Cape Cod Community College Archives.)

After the war, training continued in the area. Here, in the summer of 1928, two cadets from the 1st Corps Cadets of Boston are pictured at Town Neck Beach in front of an anti-aircraft gun. They are Florence Grady (left) and Ida McHugh. (Courtesy Sandwich Town Archives.)

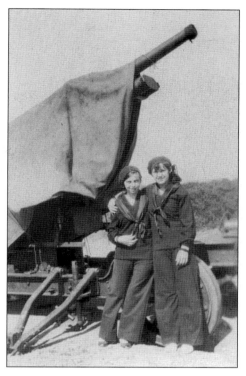

In 1935, about 25,000 acres in parts of Sandwich, Bourne, and Mashpee were taken by the state for the National Guard. The camp was named for Maj. Gen. Clarence R. Edwards, commander of the 26th Division (called the Yankee Division) in World War I. (Courtesy Sandwich Historical Society Archives.)

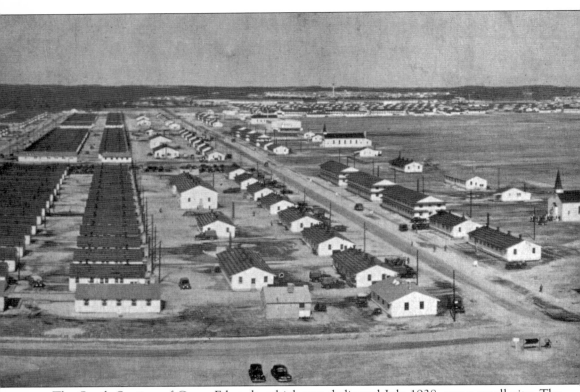

The South Section of Camp Edwards, which was dedicated July 1938, was a small city. The Yankee Division, which included everyone who had joined since 1919, formed a parade 12 miles long. The reviewing stand held the governor and many state dignitaries, while a crowd 50,000 strong came to watch the event. (Courtesy Cape Cod Community College Archives.)

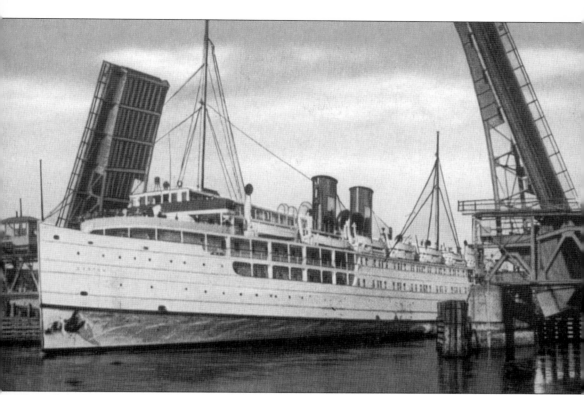

Meanwhile, heavier traffic was transiting the Cape Cod Canal and more was anticipated. Here, the steamer *Boston* passes through the canal under the Sagamore raised bridge. (Courtesy Cape Cod Community College Archives.)

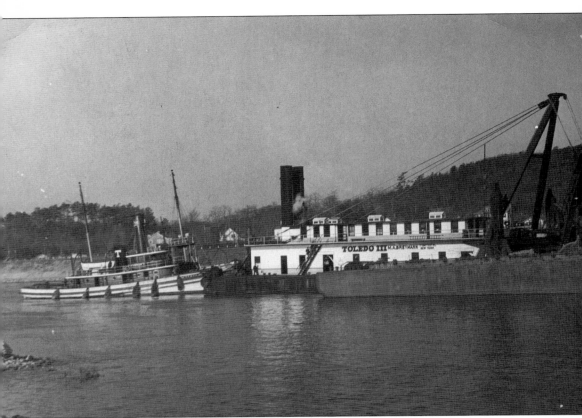

In 1928, the government took over the Cape Cod Canal, putting the U.S. Army Corps of Engineers in charge. Many changes were made, one of which was to widen the canal from 100 to 170 feet at the bottom, with a 25-foot depth. Here, the dredge *Toledo III* is being pushed by a tug just prior to the widening. This view is from the Cape to the "mainland." (Courtesy Sandwich Historical Society Archives.)

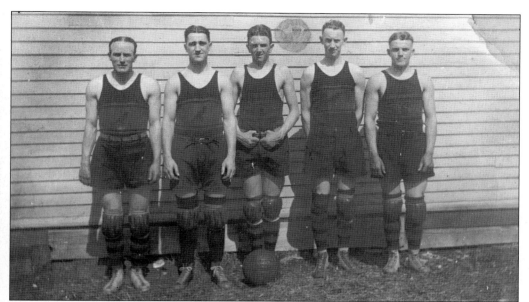

The Sandwich basketball team is shown complete with knee guards and ball in the 1930s. (Courtesy Sandwich Historical Society Archives.)

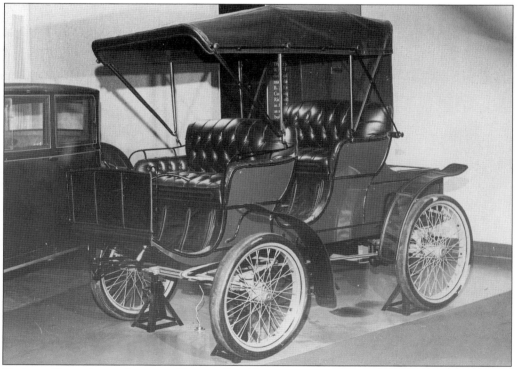

Heritage Plantation at the upper Shawme Pond has many reminders of early Sandwich, including its offices, which are in a 1687 Wing family home. Pictured here is the earliest car in the Antique Automobile Collection, an 1899 Winton. The plantation also has a superb rhododendron collection begun by Charles O. Dexter, an earlier owner. (Courtesy Heritage Plantation.)

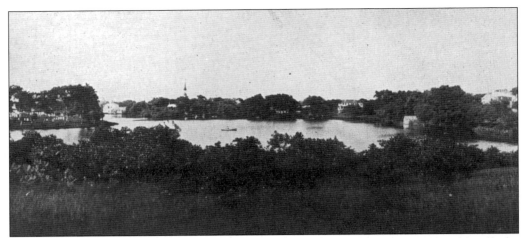

A view of Lower Shawme Lake shows, from left to right, the town cemetery, the old mill, the Sandwich Town Hall, the Congregational church spire, an old Colonial home, and "the Willows." (Courtesy Sandwich Historical Society Archives.)

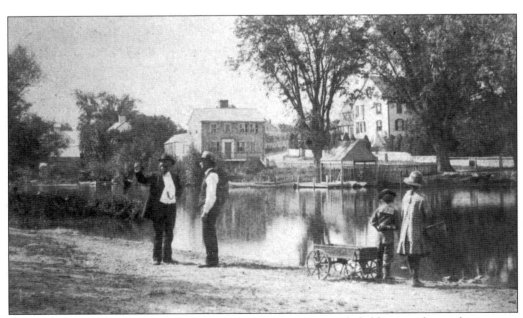

This close-up of Shawme Pond shows two men conversing and children at play with a wagon. (Courtesy Sandwich Town Archives.)

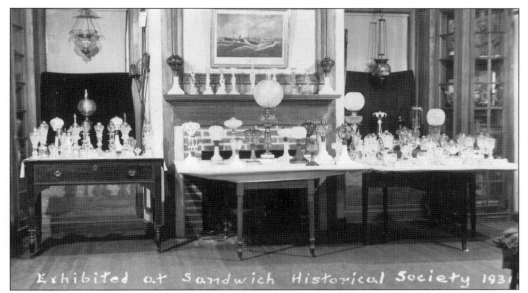

Exhibited at Sandwich Historical Society 1931

This varied group of lamps was displayed at the Sandwich Historical Society in 1931 on both a table and a fireplace mantle. (Courtesy Sandwich Historical Society Archives.)

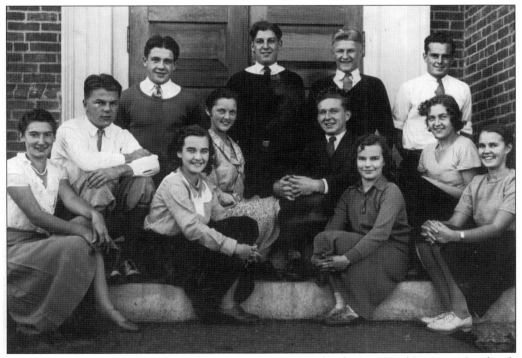

This senior class graduated from the Henry T. Wing School in 1932. (Courtesy Sandwich Historical Society Archives.)

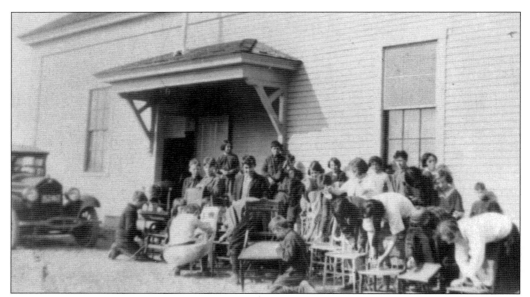

A group is learning chair caning in 1925 in front of the former Sand Hill School on Dewey Street. (Courtesy Sandwich Town Archives.)

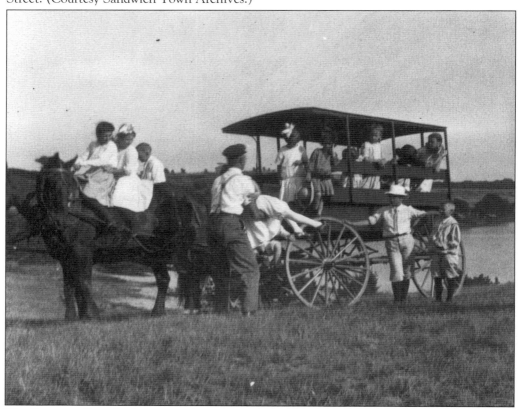

The Freeman Farm had many gatherings, including this one where mostly young people are enjoying a wagon ride at Peter's Pond. (Courtesy Sandwich Town Archives.)

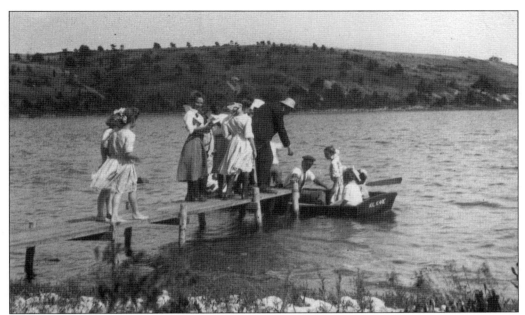

In this photograph, more of the Freemans are enjoying boat rides on Peter's Pond. (Courtesy Sandwich Town Archives.)

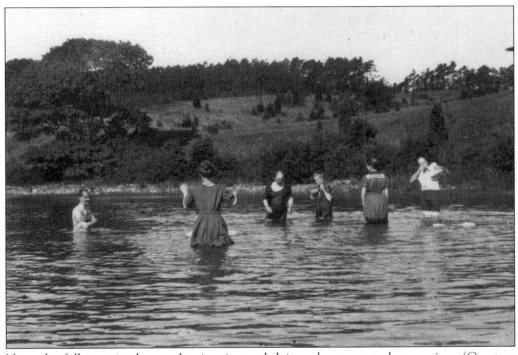

Now, the folks are in the pond swimming and doing what seem to be exercises. (Courtesy Sandwich Town Archives.)

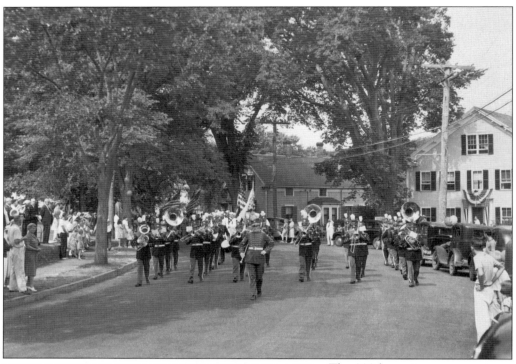

The 300th-anniversary occasion of the town of Sandwich in 1939 featured a parade beginning with the band. (Courtesy Sandwich Town Archives.)

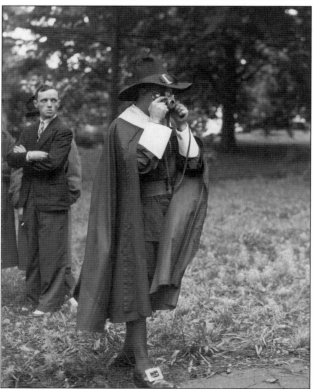

William Fish, in Pilgrim costume, is making a permanent record of the event. (Courtesy Sandwich Town Archives.)

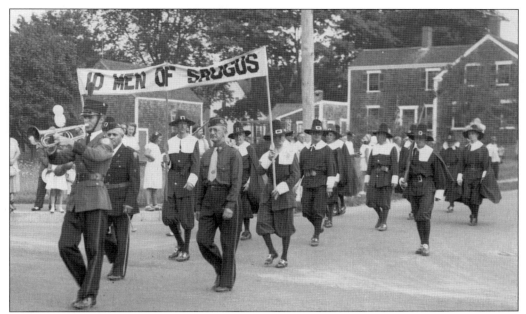

"The Ten Men of Saugus" in Pilgrim costume followed, although there are definitely more than 10 men here! (Courtesy Sandwich Town Archives.)

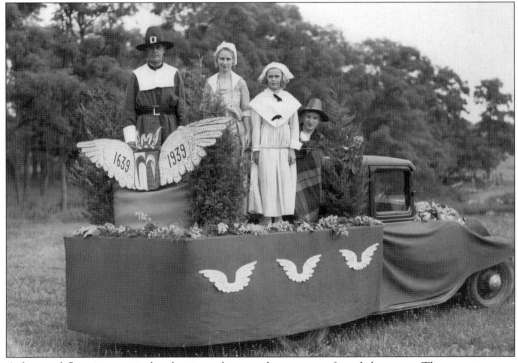

A featured float is a reminder that it took more than men to found the town. There were many families who moved to Sandwich initially. (Courtesy Sandwich Town Archives.)

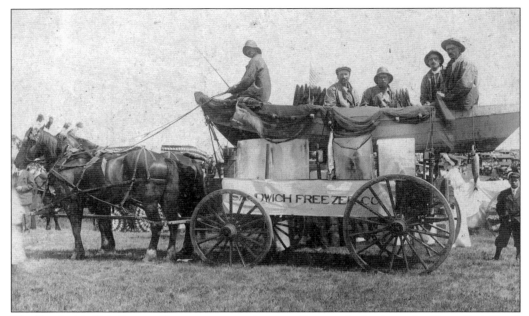

The Sandwich Fish Freezer Company wagon in an earlier parade (perhaps the Cape Cod Canal opening) features five men sitting in a boat. (Courtesy Sandwich Town Archives.)

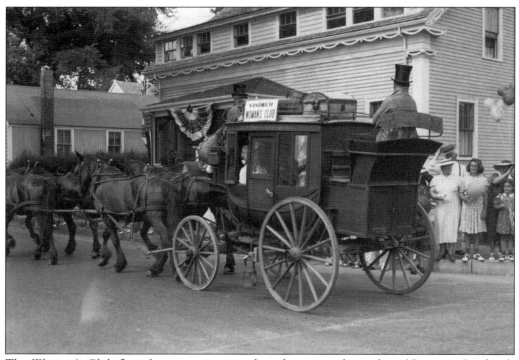

The Women's Club float features a stagecoach with costumed travelers. (Courtesy Sandwich Town Archives.)

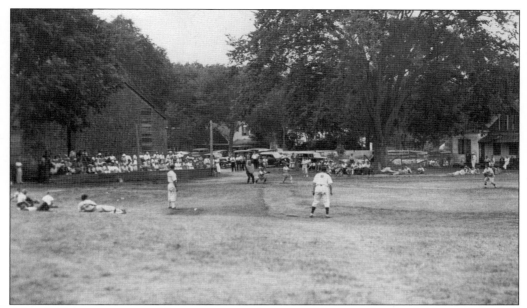

A baseball game was part of the tercentenary festivities. (Courtesy Sandwich Town Archives.)

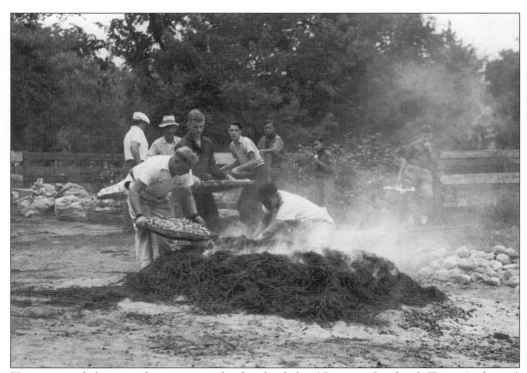

Here is a good close-up of preparations for the clambake. (Courtesy Sandwich Town Archives.)

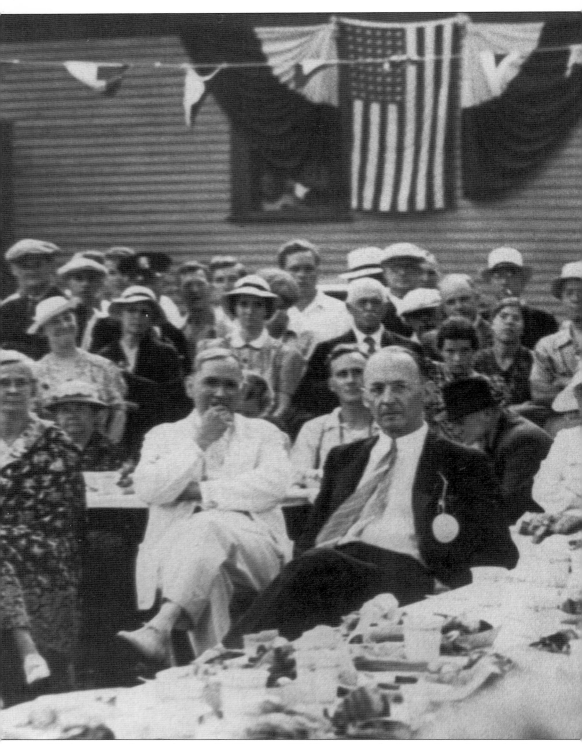

Native son, author, and naturalist Thornton W. Burgess was the featured speaker at the dinner.

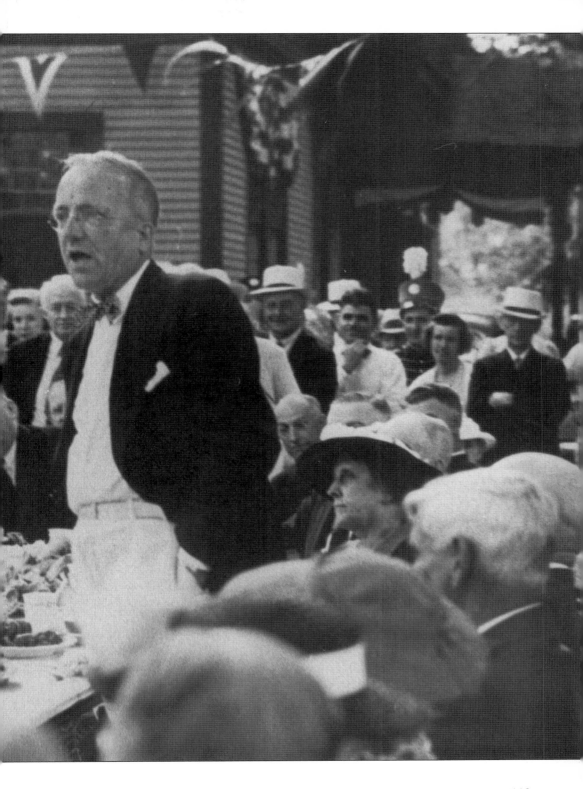

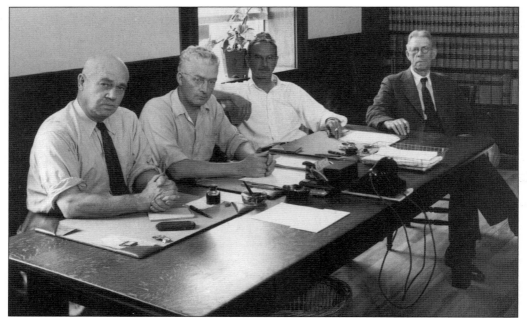

From left to right, selectmen George Meiggs, George Mooney, and Frederick Pope and town clerk Frank Howland pose during the tercentenary year, 1939. (Courtesy Sandwich Town Archives.)

Radio personality Ray Hall is interviewing Annie Rose, who lived to be over 100 years of age. (Courtesy Sandwich Town Archives.)

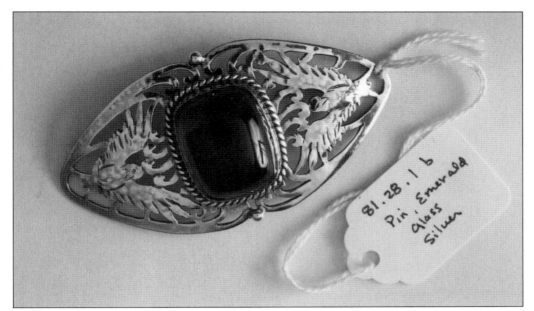

About this time, many craftsmen used shards of glass from the old factory to create pieces of jewelry like this pin by Hazel Blake French. Her work had been on exhibit in the Davis Museum and Cultural Art Center of Wellesley College and the National Museum of American Art in the Smithsonian Institution. (Courtesy Sandwich Historical Society Archives.)

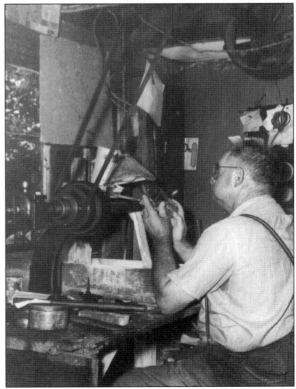

Another local artist was Henry Willis Hoxie, shown cutting glass c. 1950 at his home on Route 6A. (Courtesy Sandwich Town Archives.)

The Fish Hatchery began c. 1924, when part of the Nye property was given to the Massachusetts Division of Fish and Wildlife. Here, the fish are being fed in the hatchery, which is still operating. (Courtesy Town of Sandwich Archives.)

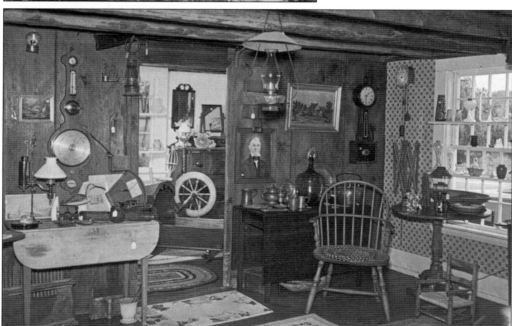

The Old Time Shop in East Sandwich featured early Colonial furniture, Sandwich glass, and clocks. The shop was in the ell of a 1698 house, which had been a tavern as well as the first post office and general store. Walter and Rosanna Cullity were the proprietors in the 1960s and 1970s. (Courtesy Sandwich Town Archives.)

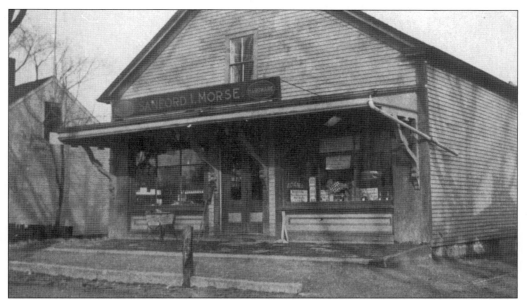

The Sanford I. Morse hardware store, on Jarves Street, was formerly the building of the first Catholic chapel, erected in 1830. The store is pictured here *c.* 1900. (Courtesy Sandwich Town Archives.)

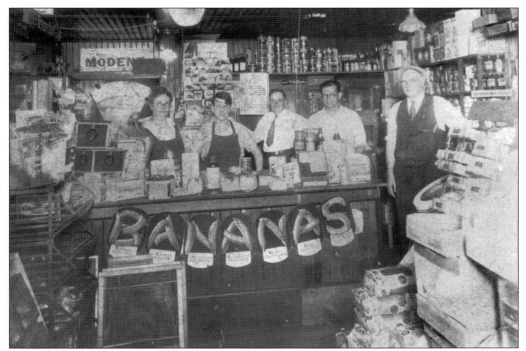

The interior of Smith's grocery store, on Liberty Street, is shown *c.* 1931. From left to right are Zuleme (Fish) Smith, Ann Kelly, the Reverend Orrin Griswold, Blake Norris, and Will Shepardson. (Courtesy Sandwich Town Archives.)

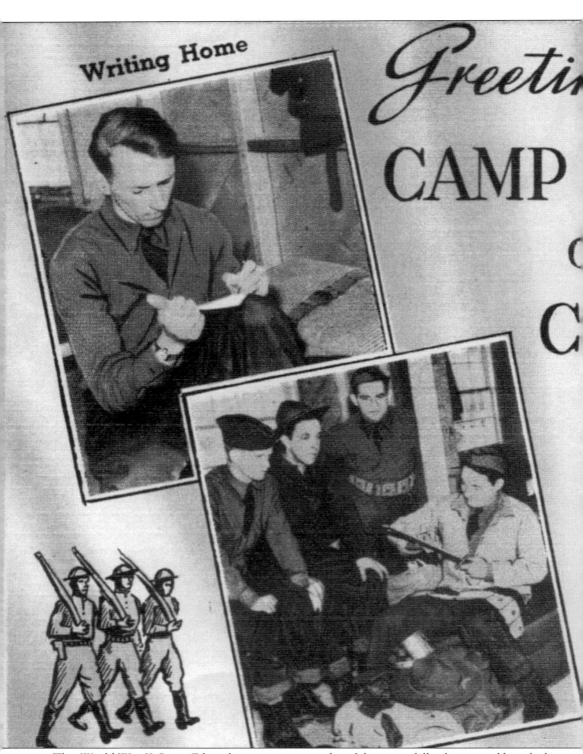

This World War II Camp Edwards poster is a reminder of the many folk who trained here before

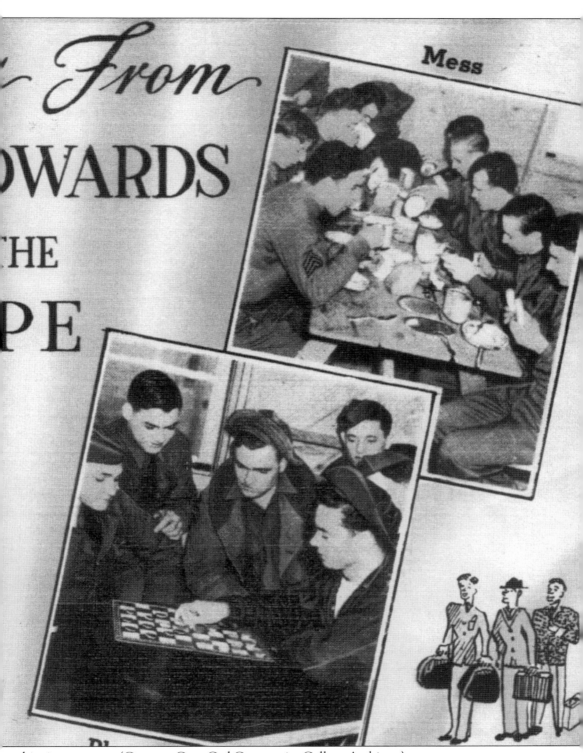

shipping overseas. (Courtesy Cape Cod Community College Archives.)

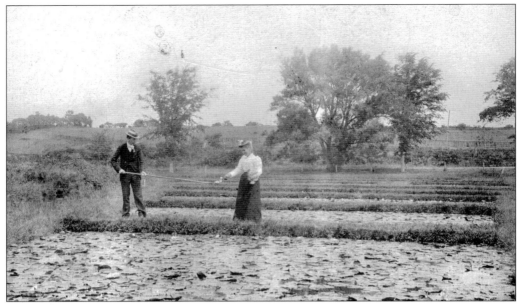

William Chipman and his wife are seen here inspecting their lily ponds. The pink lilies were sold to people all over the country. When Thornton Burgess was a boy, one of his jobs was taking the Chipmans' packaged waterlilies to the post office. Some of these lilies had been transplanted from Red Lily Pond in Craigville. (Courtesy Sandwich Town Archives.)

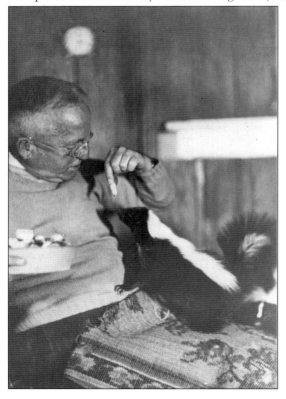

When Thornton Burgess returned to his boyhood town, he visited with some of his former neighbors and friends. One was Alice Cook at her Woodshed Nightclub. He called her "Aunt Sally" in his stories and on radio to protect her privacy. Here, he is feeding a skunk in the nightclub. (Courtesy Sandwich Historical Society Archives.)

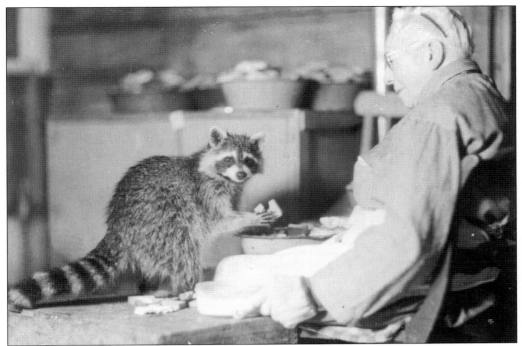

Now Aunt Sally is feeding a raccoon, who is also one of the guests at the night club. She spent a great deal of time preparing food for her four-footed guests. (Courtesy Sandwich Historical Society Archives.)

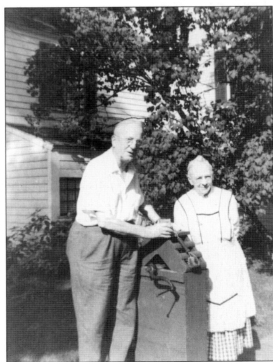

Thornton Burgess and Alice Cook are seen standing in her yard by her well on her 90th birthday. (Courtesy Sandwich Historical Society Archives.)

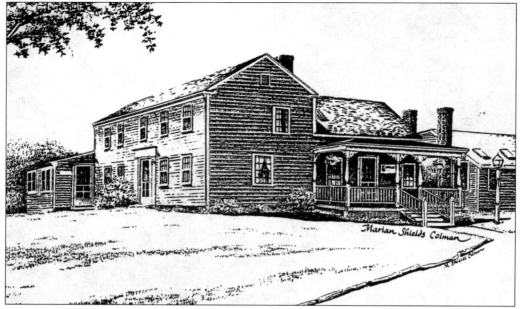

Another of Thornton Burgess's interests was the work at Green Briar Jam Kitchen. Additions were made to the home to allow for a shop, as well as sufficient room to make jam. (Courtesy Green Briar Nature Center and Jam Kitchen.)

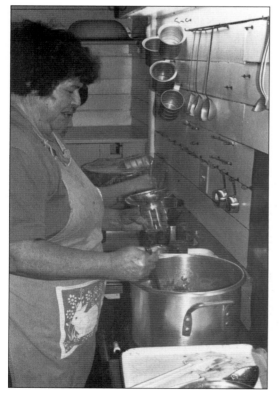

Former staff member Jeanne Anderson is making jam using stoves. Though not pictured here, soft berries are also made into jam by placing them in solar windows. (Courtesy Green Briar Nature Center and Jam Kitchen.)

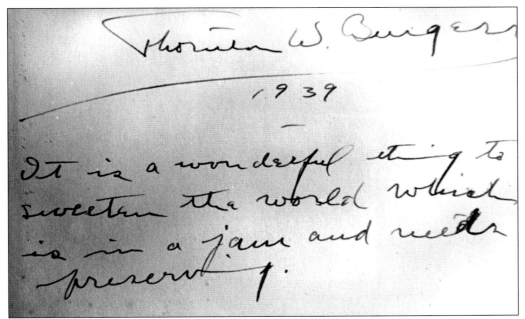

It is a wonderful thing to sweeten the world which is in a jam and needs preserving.

Thornton W. Burgess wrote this inscription on a book given to Martha Blake at the Green Briar Jam Kitchen on March 22, 1980. (Courtesy Sandwich Historical Society Archives.)

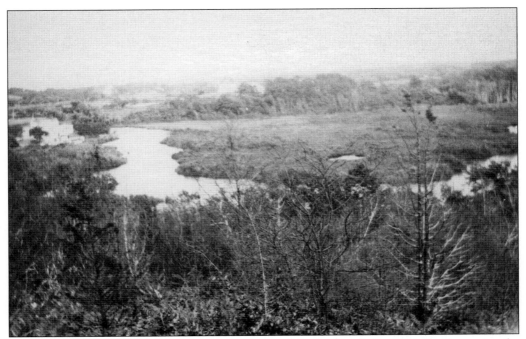

Bordering Green Briar Nature Center are the Smiling Pool and the Briar Patch, setting for many of Burgess's stories. The latter is a conservation area with six nature trails. (Courtesy Sandwich Town Archives.)

One of the early homes in East Sandwich was a three-quarter house, originally in the Freeman family and now both a home and a bookshop. (Photograph by Marion Vuilleumier.)

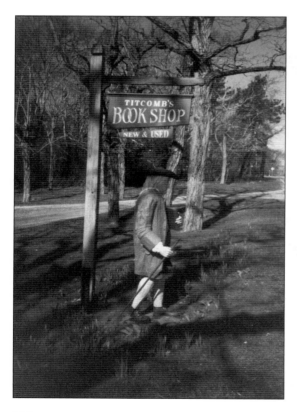

In front of the home is a statue created by Ted Titcomb, reminding people that Sandwich and the Cape have always had writers and book lovers. (Photograph by Marion Vuilleumier.)

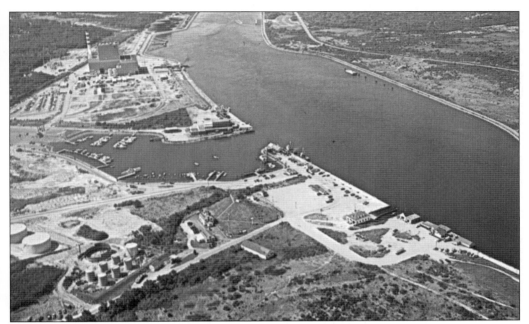

This air view shows the Sandwich Marina on the Cape Cod Canal, the electric plant, and the Coast Guard station. (Courtesy Sandwich Historical Society Archives.)

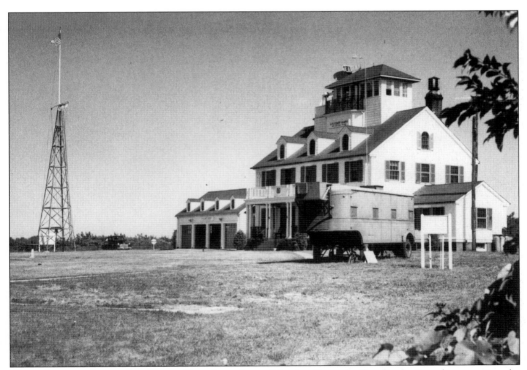

This close-up shows the Coast Guard station with the flagpole for displaying distress signals. (Courtesy Cape Cod Community College Archives.)

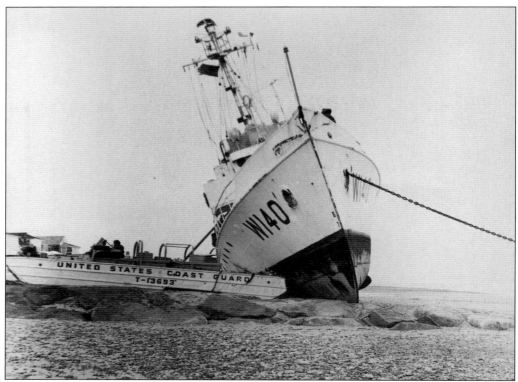

The ship *General Greene* is shown here after grounding in the Cape Cod Canal on March 4, 1960. (Courtesy Sandwich Town Archives.)

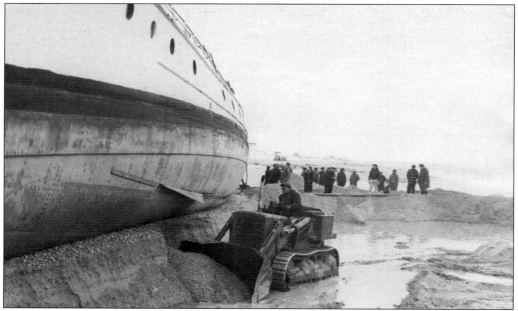

Canal "superintendents" watch efforts to refloat the *General Greene*, which were successful on March 8, 1960. (Courtesy Sandwich Town Archives.)

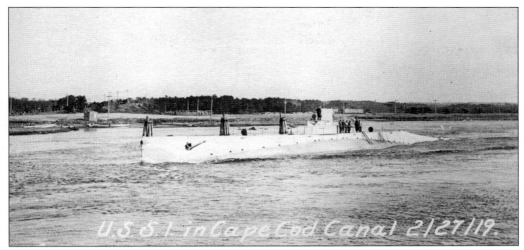

A portent of the future happens as a U.S. Navy submarine transits the Cape Cod Canal. (Courtesy Sandwich Historical Society Archives.)

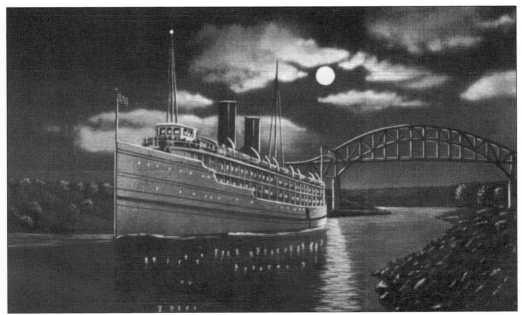

One of the sightseeing excursions people used to enjoy was driving to the Cape Cod Canal to watch the Boston–New York boat pass through at night. Here, it is framed by one of the bridges. (Courtesy Sandwich Historical Society Archives.)

BIBLIOGRAPHY

Barbour, Harriot Buxton. *Sandwich: The Town That Glass Built*. Clifton, New Jersey: Augustus M. Kelley Publisher, 1972.

Cullity, Rosanna and John Nye Cullity. *A Sandwich Album*. Sandwich, Massachusetts: Nye Family of America Association, 1987.

Hassell, Martha. *The Challenge of Hannah Rebecca*. Sandwich, Massachusetts: Sandwich Historical Society, 1986.

Lovell, Russell A. Jr. *Sandwich: A Cape Cod Town*. Sandwich Massachusetts: Town of Sandwich, Massachusetts Archives and Historical Center, 1986.

Vuilleumier, Marion. *Cape Cod: A Pictorial History*. Virginia Beach, Virginia: The Donning Company, 1982, Second Printing 2000.

———. *Churches on Cape Cod*. Taunton, Massachusetts: William S. Sullwold Publishing, 1974.

———. *Sketches of Old Cape Cod*. Yarmouth, Massachusetts: Craigville Press & Video, Fifth Printing, 1998.

———. ed. *Three Centuries of the Cape Cod County, Barnstable Massachusetts 1685–1985*. Barnstable, Massachusetts: Barnstable County, 1985.